American Material Culture and the Texas Experience

The David B. Warren Symposium

Volume 1

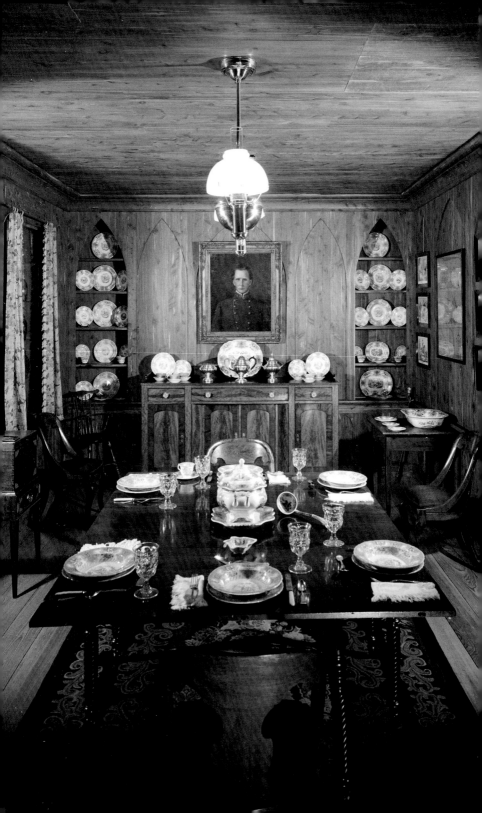

American Material Culture and the Texas Experience

The David B. Warren Symposium

Volume 1

Bayou Bend Collection and Gardens
The Museum of Fine Arts, Houston

This publication is based on papers delivered at the inaugural David B. Warren Symposium, "American Material Culture and the Texas Experience," presented by Bayou Bend Collection and Gardens at the Museum of Fine Arts, Houston, on February 9–10, 2007.

If you would like to support the Endowment Fund for the biennial David B. Warren Symposium, please send your contribution to Bayou Bend Collection and Gardens, P.O. Box 6826, Houston, Texas 77265-6826.

Edited by Christine Waller Manca
Book design by Janet Young
Printing by Masterpiece Litho, Inc.

Printed in the United States of America

Library of Congress Cataloging-in-Publication Data

David B. Warren Symposium.
 American material culture and the Texas experience : the David B. Warren Symposium.
 p. cm.
 Publication based on papers delivered at the inaugural David B. Warren Symposium, "American Culture and the Texas Experience," presented by Bayou Bend Collection and Gardens at the Museum of Fine Arts, Houston, Feb. 9-10, 2007.
 "Volume 1."
 ISBN 978-0-89090-168-7 (pbk. : alk. paper)
 1. Decorative arts--United States--Congresses. I. Bayou Bend Collection. II. Museum of Fine Arts, Houston. III. Title.
 NK805.D35 2009
 745.0973--dc22

 2009000711

Front cover: Attributed to Wenzel Friedrich, San Antonio, Texas. **Spring Rocking Chair.** *c. 1885–95. Steer horn, horn veneer, jaguar hide, iron, chrome-plated iron, and wood, 37 ½ x 30 ½ x 31 in. (95.3 x 77.5 x 78.7 cm). The Museum of Fine Arts, Houston, gift of William J. Hill, 83.138.*
Back cover: The Texas Room at Bayou Bend, 2006.
Frontispiece: The Texas Room at Bayou Bend, 1960.

Generous funding to assist with this publication was provided by:
Carol and Les Ballard
William J. Hill
Nancy Glanville Jewell
Mrs. Frederick R. Lummis

The 2007 David B. Warren Symposium received generous support from
The Summerlee Foundation, McCrea Foundation, Leslie and J. Abbott Sprague,
The Texas Historical Foundation, and Humanities Texas.

The David B. Warren Symposium receives permanent income
from endowment funds provided by Isabel B. and Wallace S. Wilson,
Mr. and Mrs. Mark Abendshein, the Audrey Jones Beck Estate,
The Brown Foundation, Inc., Betsy D. and Hugh Ghormley,
Lora Jean Kilroy, and Mr. and Mrs. Robert P. Ross, Jr.

Additional endowment gifts were received from the George and Anne Butler Foundation,
Lee and Joe Jamail, the Kennedy Trust, the John P. McGovern Foundation,
the Stedman West Foundation, Mr. and Mrs. Charles W. Tate, Mr. Fayez Sarofim,
Mr. and Mrs. A. Clark Johnson, Dr. and Mrs. Frederick R. Lummis, Jr.,
and the Payne Foundation.

Contents

"Texas, an empire in itself, geographically and historically, sometimes seems to be regarded as remote or alien to the rest of our nation. I hope in a modest way that Bayou Bend may serve as a bridge to bring us closer to the heart of an American heritage which unites us."
—*Miss Ima Hogg, 1966*

Legendary Houston philanthropist and collector Miss Ima Hogg (1882–1975) assembled one of the world's finest collections of early American decorative arts and paintings. In an extraordinary act of generosity and vision, she gave her collection and her fourteen-acre estate—Bayou Bend—to the Museum of Fine Arts, Houston, in 1957. Since opening to the public in 1966, Bayou Bend has served as the bridge Miss Hogg envisioned, sharing with visitors the unique story of America's heritage and culture and Texas's connection to that story.

Just as she had an unerring eye for quality when selecting objects for her collection, so too did Ima Hogg choose well when she hired David B. Warren in 1965 to guide Bayou Bend in its new roles as a museum, public gardens, and educational institution. David's renowned thirty-eight-year tenure led the trustees of the Museum of Fine Arts, Houston, to name him Founding Director Emeritus of Bayou Bend upon his retirement in 2003. To further recognize his service and honor his scholarship, the museum established a biennial symposium in his name: The David B. Warren Symposium on American Material Culture and the Texas Experience. The primary objective of the symposium is to place the pre-1900 material culture of Texas, the lower South, and the Southwest within a national and international context. The influences of the distinctive societies that migrated to these regions of the United States, as well as the confluence of their cultures, will be examined over the course of successive symposia, providing an important forum for scholars in American material culture and related fields.

Following are the proceedings of the inaugural David B. Warren Symposium, organized by Bayou Bend and museum staff and held at the Museum of Fine Arts, Houston, from February 9 to February 11, 2007. The papers, presented by five distinguished scholars from across the country, cover a wide range of topics, and suggest the variety and depth of subjects available for further discovery, investigation, and analysis. By publishing the proceedings of each symposium, the museum will help to build a much-needed critical literature on the material culture of Texas, the lower South, and the Southwest, that establishes the field as integral to the broader landscape of American material culture.

Appropriately, this first volume of proceedings is introduced by the paper Mr. Warren presented at the first conference, a fascinating essay that provides a firm basis and raison d'être for the symposium's overall theme. David chronicles Miss Hogg's life-long effort to bring American colonial and Federal objects—material culture—to Texas, and reveals the tremendous influence she had on others in Houston and the region to collect and preserve colonial material from the eastern United States. He also discusses the existence of a "Texas Room" at Bayou Bend, which reinforced the historical link between Texas and America.

Because this is the first in a series of symposia about American material culture, it was important to have a strong grasp of what is meant by "material culture." Dr. Margaretta M. Lovell, the symposium's keynote speaker, goes well beyond a definition of the term, offering a cogent analysis of the method, theory, and subject of American material culture. Her overview of the history of thinking about things American is illuminating and provides a solid foundation for the inaugural symposium and all future symposia.

Three papers begin in three different geographic areas of America to address the symposium's overall objective to place Texan, southern, and southwestern material culture within a national and international context. Consistent with Dr. Lovell's discussion, the essays demonstrate how thinking about an object

from a material culture perspective reveals a more compelling story than merely its aesthetic merits. Dr. Kelly Donahue-Wallace mines a 1741 probate inventory of the San Antonio de Béxar presidio commander to conclude convincingly that the material culture of Spanish colonial Texas included objects from not only New Spain, but also Asia and Europe. Mr. Lonn Taylor discusses the large immigration of Germans to America and their persistent cultural impact on the built environment and furniture of central Texas, where thousands settled between 1830 and 1860. Ms. Jill Beute Koverman explores the pottery tradition of Edgefield, South Carolina, during the nineteenth century and weaves craftsmanship together with economics and business, scientific discovery, social interaction, and westward expansion into Texas.

The evolution of the David B. Warren Symposium—from concept, to inaugural presentation, to publication of volume one of the series' proceedings— involved the creativity, guidance and assistance of many individuals and organizations. Our special thanks to the Trustees of the Museum of Fine Arts, Houston, and the members of the Bayou Bend Committee, for supporting the symposium concept and the creation of a symposium endowment fund. Many people made generous, early contributions to establish the endowment; a list of the lead donors may be found on page v, but we also wish to recognize here the generosity of Isabel B. and Wallace S. Wilson, Mr. and Mrs. Mark Abendshein, the Audrey Jones Beck Estate, The Brown Foundation, Inc., Betsy D. and Hugh Ghormley, Lora Jean (Jeanie) Kilroy, and Mr. and Mrs. Robert P. Ross, Jr. There is an ongoing effort to increase the endowment to ensure the growth and success of the symposium program.

The symposium's recurring theme—American Material Culture and the Texas Experience—was developed by a team of Bayou Bend and MFAH staff members representing the curatorial and education disciplines: Michael K. Brown,

Katherine S. Howe, Emily Ballew Neff, Kathleen O'Connor, and Beth B. Schneider. The content of the inaugural symposium was ably guided by a four-member advisory panel: Dr. John Boles, Rice University; Ms. Sarah Booth, Harris County Public Library; Dr. Don Carleton, Center for American History at the University of Texas; and Dr. P. Lynn Denton, then at the Bob Bullock Texas State History Museum and now at Texas State University. The successful presentation of the February 2007 symposium was due to the combined talents of many MFAH and Bayou Bend staff members, most notably Andre Deshotels, MariAlice Grimes, Joseph Milillo, Kathleen O'Connor, Margaret Mims, Sara Wheeler, Sally White, and Janet Young.

The inaugural conference would not have been possible without generous support from The Summerlee Foundation, McCrea Foundation, Leslie and J. Abbott Sprague, Texas Historical Foundation, and Humanities Texas. Special thanks are extended to Bayou Bend supporters who hosted various events: Bobbie and John Nau, Marilyn and Fred Lummis, Nancy and Dan Japhet, and Susu and Robert Ross, Jr. The publication of the proceedings was assisted by gifts from Carol and Les Ballard, William J. Hill, Nancy Glanville Jewell, and Mrs. Frederick R. Lummis.

We share this volume of essays with you, excited by the encouragement the museum is providing to future scholars to explore the material culture of the lower South, the Southwest, and Texas so that their findings might be presented and published by the Museum of Fine Arts, Houston, in connection with the biennial David B. Warren Symposium on American Material Culture and the Texas Experience.

Peter C. Marzio
Director
The Museum of Fine Arts, Houston

Bonnie A. Campbell
Director
Bayou Bend Collection and Gardens

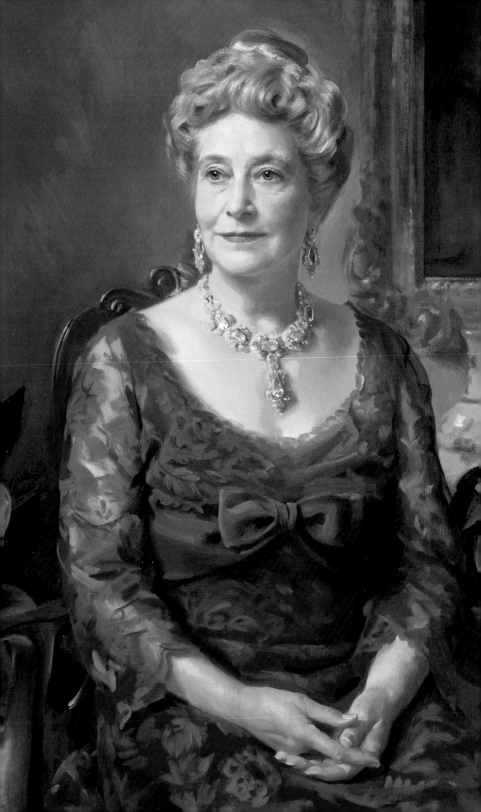

Introduction

A Gift of Love:
Miss Ima Hogg's Quest to Bring
Americana to Texas

David B. Warren

The purpose of this essay is to consider Ima Hogg's quest to bring colonial Americana, or early American material culture, to use a more modern term, to Texas. Without Ima Hogg (fig. 1), there would be virtually no early American material culture in Texas today. Not surprisingly, the greatest concentration of examples of early American material culture in the state is here in Houston. Nearly all the other important collecting of Americana in Houston was influenced, in one way or another, by Ima Hogg's collecting and by her gift of her collection to the public. Notable among those collectors influenced by Miss Hogg were Mr. and Mrs. James Britton, who themselves gave several important pieces to Bayou Bend and whose remaining collection was later sold with great fanfare at auction; and Charles and Faith Bybee, whose fine, albeit small, collection is now at the Dallas Museum of Art. Why is this so? It comes down to a variation of the old saying, "I don't know much about art, but I know what I like"; in this instance, the refrain would be, "I *like* what I *know*." Because her collection ultimately entered the public domain, as the Bayou Bend Collection of the Museum of Fine Arts, Houston, the

pattern of transferring colonial American material from the eastern United States became familiar and comfortable to the public and inspired collecting. How, then, did this come about?

At the March 1966 dedication of Bayou Bend, many years after she started to collect, Miss Hogg noted, "The Bayou Bend Collection was always destined for the public. From the time I acquired my first country Queen Anne armchair in 1920, I had an unaccountable compulsion to make an American collection for some Texas museum."[1] Like her father, Texas governor James Stephen Hogg, Ima Hogg always strove to make Texas a better place. Her intention in the 1920s, to form a collection to give to a museum in Texas, might not seem radical today, but let's put it into context. In 1920, when she bought her first piece, there were no museums in Texas. It was not until 1924, when the Metropolitan Museum's American Wing opened in New York, that any museum exhibited American decorative arts on a permanent basis.

From the outset, it was her impulse to share with others. The origin of that impulse can likely be traced to Ima Hogg's own experience in 1920 when she saw a piece of colonial American furniture (fig. 2, right)—a chair in Wayman Adams's New York studio where Ima was sitting for her portrait (fig. 3). She was very surprised and excited to discover that it had been made in colonial New England, as she had been unaware of the survival of colonial American furniture.

It was that experience that led to her first purchase of Americana, a country Queen Anne chair (see fig. 2, left). Forty-eight years later, in 1968, when Bayou Bend was already open as a museum, she had the opportunity to purchase the Adams chair from his descendants. As curator of Bayou Bend, I was with Miss Hogg when it arrived and was unpacked. "Oh, it's a dumb chair," she commented, "I don't know why I got so excited." I responded, "But I'm so glad you did! Look what happened—none of this would be here if you didn't." The incident represents a microcosm of what she accomplished and of the subject of this symposium, the transfer of Americana to Texas. Although in 1920 she knew nothing about Americana, she had an innate eye for quality, so the chair she purchased then was actually much finer than the example that had inspired her.

Why did Miss Hogg, an educated and well-to-do woman in her late thirties, not know about colonial American furniture? In great part, it is because there were few, if any, examples in Texas at that time. After all, in Texas one cannot go down to the local historic house and be immersed in pre-Revolutionary culture. Yet Ima

Fig. 2. The first American antique that Miss Hogg acquired (left) and the Queen Anne chair that first inspired her collection (right). Left: Unknown maker, New England. **Armchair**. 1735–90. Soft maple and ash, 45 ¼ x 25 ¼ x 21 ¾ in. (114.9 x 64.1 x 55.2 cm). The Bayou Bend Collection, gift of Miss Ima Hogg, B.20.1. Right: Unknown maker, New England. **Armchair**. 1735–90. Soft maple, and birch; ash, 45 ½ x 24 x 23 ½ in. (115.6 x 61 x 59.7 cm). The Bayou Bend Collection, gift of Miss Ima Hogg, B.68.3.

Fig. 3. Wayman Adams. **Miss Ima Hogg**. c. 1920. Oil on canvas, 24 ⅛ x 20 ⅛ in. (61.3 x 51.1 cm). The Bayou Bend Collection, gift of Alice C. Simkins, B.79.292.

Hogg always felt that a Colonial heritage belonged to all Americans, not only those living on the Atlantic seaboard. Her lack of knowledge about the material culture of the era was not for a lack of interest in history or old things.

Her recollections of her childhood during her father's tenure as Texas governor included the thrill of sleeping in the antebellum four-post bed (fig. 4) that Sam Houston had bought for the Governor's Mansion in Austin (fig. 5).[2] She also undoubtedly lived with an 1850s walnut wardrobe with mirror doors which appears in a November 1861 inventory of the mansion.[3] What she did not know then was that it was made in Texas. Visits to her maternal grandparents, James and Mary Stinson in East Texas, exposed her to other antebellum family pieces, including a square rosewood piano and a bureau. Ima vividly remembered her great-aunt Lizzie Stinson Philips pointing out a an old bureau and telling her that it had belonged to Ima's great-grandmother.[4] The bureau was probably from the 1820s.

Fig. 4. The Sam Houston bed in the Texas Governor's Mansion in Austin. Courtesy the Friends of the Governor's Mansion, Austin.

Fig. 5. The Governor's Mansion, Austin, 1870. Courtesy the Friends of the Governor's Mansion, Austin.

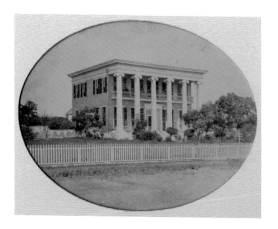

The Sam Houston bed and the Texas wardrobe date to the 1850s, and the square rosewood piano probably dates to about the same time. Although all of these objects she encountered in her childhood were old, they were far in date from the colonial period.

When Ima was eleven years old, she accompanied her father on a trip to the East; they spent most of the time in New York City but also took a jaunt to Providence, Rhode Island. She wrote home to her mother in Austin about being entertained there by the leading families and a party held in her honor.[5] It is highly likely that during her time in Providence, Ima came in contact with examples of colonial Rhode Island furniture, even if she did not consciously remember it.

To fully understand Ima Hogg's contribution to the transfer of colonial American material culture to Texas, it is necessary to look at what her older brother, William Clifford Hogg, known as Will, was doing at the same time (fig. 6). In the nineteen-teens the Hogg siblings retained Houston architect Birdsall Briscoe to remodel Varner Plantation, an antebellum house in West Columbia, Texas, purchased by their father in 1901 (fig. 7). The project greatly altered the appearance of the house, creating something that evoked Mount Vernon, with a soaring portico and cupola (fig. 8). Indeed, Will said, "I tried to fix up the old place as George Washington would do if he had a bank roll."[6] This wry comment expresses the Hoggs' interest in the Colonial Revival style and in transferring it to Texas. As early as January 1920, Will had purchased a Federal card table, today part of the collection at Bayou Bend. The next year, the Hoggs began to construct a family office building downtown, which was topped by a penthouse office suite. Ima took great interest in the details of the office's Colonial Revival style interior, making suggestions for the style of the fenestration, the white paint for the woodwork, and the black colonial-style hardware for the doors and windows. The offices were furnished with Will Hogg's collection of Windsor furniture and Ima's early American glass and hooked rugs. Will's collection of Frederick Remington paintings hung on the walls. To a great extent, the Hogg Brothers office served as an incubation stage for what was to come at the end of the decade in the form of the Hoggs' new house, Bayou Bend.

Thus we can see that Will and Ima both were collecting at the same time. Ima made it clear in early 1921 that she wanted to do something important in collecting Americana when she wrote Will, "I want to make you a proposal. As I have my own ideas about antiques and furniture, and am fond of collecting them, let me do this. I missed a wonderful opportunity in the fall. You'd be amazed at

the scarcity of American things."[7] This letter is key because it not only sets out her collecting ambitions but also reflects a major challenge to her aims—the source for Americana was far away from Texas. It was evident that the transfer of colonial American material culture to Texas was not something easily accomplished.

Another challenge in the early 1920s was the lack of books on American furniture and glass. Miss Hogg initially found that the main sources of information were the dealers, and she patronized only the very best, such as Collings and Collings, Israel Sack, and Ginsburg and Levy. Auctions were also a significant resource. An important professional link was forged in the mid-1920s, when she met Charles O. Cornelius, the curator of the American Wing at the Metropolitan Museum of Art. She later noted that Cornelius was of great assistance to her in her early collecting.[8] Their introduction very likely came through John F. Staub, the architect who would later design Bayou Bend. Staub was a classmate of Cornelius at Massachusetts Institute of Technology, where they graduated in 1916 with degrees in architecture.

Staub, practicing in the New York office of architect Harry T. Lindeberg, came to Houston in 1921 to supervise several local Lindeberg commissions, and eventually settled here. In 1924 Staub and Ima Hogg collaborated in the design

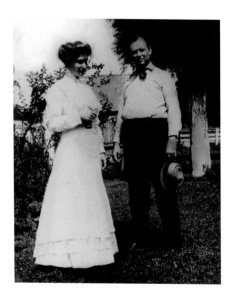

Fig. 6. Will and Ima Hogg at Varner Plantation, c. 1906.

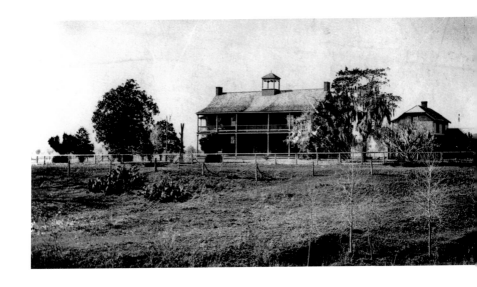

Fig. 7. Varner Plantation, West Columbia, Texas, early twentieth century. Ima Hogg Papers, Center for American History, The University of Texas at Austin (CN00997).

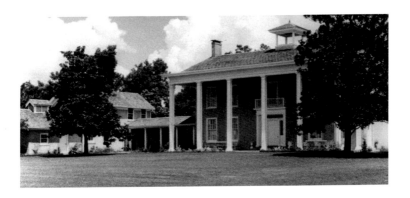

Fig. 8. Varner Plantation, after its renovation in the early 1920s. The Museum of Fine Arts, Houston, Archives.

Fig. 9. Bayou Bend, designed by John Staub, south facade.

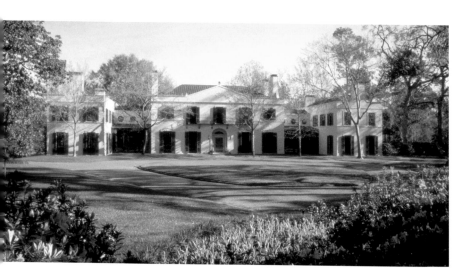

of a speculative house built for the River Oaks Corporation, thus beginning a long and fruitful friendship. The theme of stucco and black ironwork presaged what they would create three years later at Bayou Bend.[9] That same year, the American Wing opened to the public, and Cornelius published his first handbook of the Metropolitan's furniture collection. That book, along with Cornelius's 1922 opus, *The Furniture Masterpieces of Duncan Phyfe*, and his 1926 *Early American Furniture*, were listed in a 1933 inventory of Ima Hogg's library.[10] Her friendship with Cornelius and her exposure to his books were thus important influences in Miss Hogg's collecting during the mid-to-late 1920s.

Cornelius's continuing friendship with Staub is documented by a 1928 *House Beautiful* article written by Cornelius on Staub's own residence, a 1925 New England-style Colonial Revival house.[11] The very title of the article, "Transplanting the Eastern Tradition: The Residence of Mrs. John F. Staub in Houston, Texas of Which John F. Staub was the Architect," reflects the phenomenon of colonial American material culture being brought to Texas. Mrs. Staub was from Massachusetts; her husband, a native of Tennessee, embraced her New England background. The Staubs had a modest collection of New England colonial antiques, and the new house made a fine setting for them. Other than the Staubs and brother Will, there was no one in Houston with whom Miss Hogg could share her enthusiasm for bringing Americana to Texas. It was not for many years that she would meet and

establish friendships and intellectual interchanges with the giant collectors of Americana of her generation: Electra Havemeyer Webb, Maxim Karolik, Henry Francis du Pont, the Henry Flints, and, perhaps of lesser renown but still influential, Katharine Prentis Murphy.

In contrast to Mrs. Staub's New England background, Ima Hogg was a staunch and proud southerner—so it follows that colonial New England architecture was not the model she would choose. She wanted a house that was distinctively southern and reflected colonial architecture, and she admired the gracious five-part Neo-Palladian plan found in colonial-era houses like Mount Airy, on the Rappahannock River in Virginia, or George Washington's Mount Vernon (illustrated on page 55). However, she was aware of current thought on Colonial Revival architecture, which held that regional styles should be observed—for instance, a fieldstone house for Pennsylvania, a brick house for Virginia, or a clapboard or shingle-clad house—not unlike Staub's—for New England. Not only did Houston lack a Colonial architectural heritage, but none of these styles were suitable to Houston's semi-tropical climate. One might think Spanish would have been an appropriate choice, but it was unsatisfactory for Staub because the style was meant for an arid region, and for Ima because it was not southern. The inspiration for what was to become Bayou Bend has long been thought to have been New Orleans, and in fact the ironwork ultimately selected for the house came from there, but in a February 1926

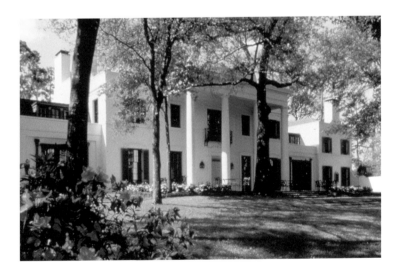

Fig. 10. Bayou Bend, north facade.

9

*Fig. 11. The Library (now known as the Pine Room),
1930. The Museum of Fine Arts, Houston, Archives.*

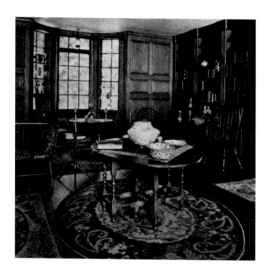

letter about the house plans, Ima wrote, "I think the elevations are very stunning
and [have] a great deal of the character of old Charleston southern houses, which
has always been much my idea."[12]

Together with Staub she created the unique house that became Bayou Bend
(fig. 9). Staub did incorporate design elements from other southern houses—like
the front door and the balcony over it based on the Nathaniel Russell House in
Charleston (built in 1808), and the elevation of the north facade (fig. 10), loosely
based on Homewood, the Carroll house in Baltimore (1805). The cast-iron balcony
of Bayou Bend's south facade, dating from the nineteenth century, came from
New Orleans. For his own house, Staub had transplanted a New England colonial
tradition to Houston; for her house, Ima Hogg transplanted a southern one.
The new house, as she wrote to her sister-in-law, Mrs. Tom Hogg, "is going to
be Southern Colonial with a Latin flavor, if there is such a thing."[13] Ultimately
she and Staub coined the term Latin Colonial, clearly a nod to the non-Anglo
heritage of New Orleans.

For the interiors at Bayou Bend, Staub created a series of rooms that were in
most cases adapted from Atlantic Seaboard colonial examples.[14] Exceptions were
the woodwork of the Library (fig. 11), based directly on a mid-eighteenth-century
New England room from the Metcalf Bowler house which Cornelius had installed

*Fig. 12. The Queen Anne Sitting Room at Bayou Bend, which
incorporates mid-eighteenth-century woodwork from Massachusetts.*

in the American Wing,[15] and Miss Hogg's personal suite, a sitting room and
bedroom on the second floor (fig. 12) that incorporated mid-eighteenth-century
period woodwork from houses in Salem and Ipswich, Massachusetts.

The period woodwork and some antique flooring were acquired during an
influential trip to New England that Miss Hogg took in the summer of 1927.
The preceding April, she had written a Boston friend, saying that she expected to
be in Massachusetts during June and July.[16] That summer, her close friends Robert
Lee Blaffer and his wife, Sarah Campbell Blaffer, of Houston rented a house in
Gloucester, Massachusetts. Ima, who had been the maid of honor in their wedding,
spent much of that summer with them. She and Sadie, as Mrs. Blaffer was known,
made motor forays around New England in search of antiques.

Among the prizes acquired by Ima were a rare Boston block-front chest of
drawers (fig. 13), a so-called cigar store Indian princess, and some seminal purchases
of American glass. The Blaffers and Ima also met and became friends with Henry
Davis Sleeper and visited his extraordinary house in Gloucester, known as Beauport.[17]
Sleeper was an early collector of Americana and colonial architecture and a decorator.
At Beauport he created magnificent tableaus of colonial material. Ima's introduction
to Sleeper was her first exposure to an important collector who shared her enthusi-
asm for Americana. One of Sleeper's brilliant innovations was the display of colored

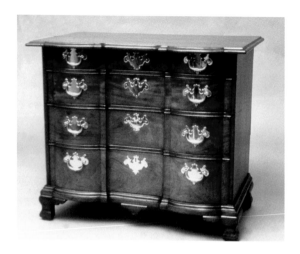

glass in a window against daylight. Ima could not have helped taking notice of
this striking feature of his interiors, and indeed the next year, when her own glass
was installed at the newly finished Bayou Bend, she used his display technique.
For Sleeper the emphasis was on the whole and the impact of massed color, whereas
for Ima the focus was on the individual piece, selected for its quality and excellence,
rather than for its decorative visual effect. This emphasis on quality and excellence
would characterize Ima Hogg's collecting throughout her career.

Ima Hogg concentrated on collecting furniture, in line with her goal of
forming a collection of colonial furniture for a museum in Texas. The early pieces
purchased in the 1920s were all of the highest quality, but they did not represent
a coherent whole stylistically. They ranged from the early eighteenth century—
including a table from New York and one from Portsmouth, New Hampshire
(fig. 14)—to the Late Baroque or Queen Anne style, including a wonderful slim-
legged tea table and a high chest, both from the Hartford/Wethersfield, Connecticut,
area and both with a history of being owned in the same family (fig. 15). From the
Rococo period, she acquired a rare chair-back settee that survived with its suite of
eight matching side chairs and a very early example of the Philadelphia high chest
form (fig. 16). Pieces from later in the century in the Neoclassical Federal style

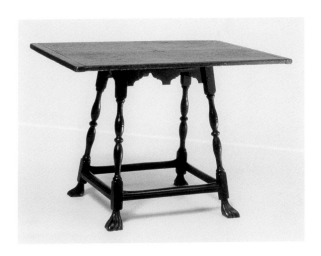

Fig. 14. Unknown maker, Portsmouth, New Hampshire, or southern Maine. **Table.** *1740–70. Soft maple and eastern white pine; white oak, 25 ½ x 36 ⅝ x 26 ½ in. (64.8 x 93 x 67.3 cm). The Bayou Bend Collection, gift of Miss Ima Hogg, B.69.351.*

include a New England lolling chair and the lady's desk now known to have been made in the Boston shop of John and Thomas Seymour (fig. 17). There is no record of how they were used at the Hoggs' home prior to Bayou Bend— 4410 Rossmoyne in the Montrose neighborhood of Houston.

Once in Bayou Bend, Miss Hogg placed her acquisitions entirely as it suited her, and not in any didactic way, even though the concept of eventual placement in a museum was in the back of her mind. For example, the Rococo chair-back settee and suite of side chairs were used in the Dining Room, where the architecture was in the Neoclassical style. Similarly, classical Phyfe-style card tables, Adamesque looking glasses, and a shield-back chair were mixed with Rococo seating furniture in the Neo-Palladian-style Drawing Room (fig. 18). The Library, reminiscent of Will Hogg's office in the Armour Building, was a wonderful Colonial Revival confection of Windsor furniture and hooked rugs (then thought to be colonial, but now known to be from the nineteenth century), along with her Native American pottery scattered about (see fig. 11).

Miss Hogg began collecting glass early on, purchasing twenty-three examples at the Jacob P. Temple sale in 1923.[18] Included were a pitcher and a green vase, at the time thought to be Stiegel and considered very rare, although today we know

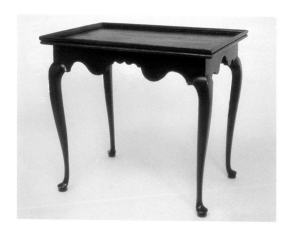

Fig. 15. Unknown maker, Hartford-Wethersfield area, Connecticut. **Tea Table.** American, 1735–82. Cherry, 26 x 29 x 20 ¾ in. (66 x 73.7 x 52.7 cm). The Bayou Bend Collection, gift of Miss Ima Hogg, B.69.349.

Fig. 16. Unknown maker, Philadelphia or Maryland. **High Chest of Drawers.** 1750–80. Black mangrove; black cherry, Atlantic white cedar, black walnut, yellow poplar, and eastern white pine, 96 ¾ x 44 x 23 ¾ in. (245.7 x 111.8 x 60.3 cm). The Bayou Bend Collection, gift of Miss Ima Hogg, B.69.64.

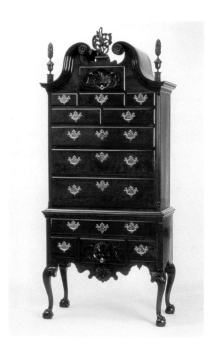

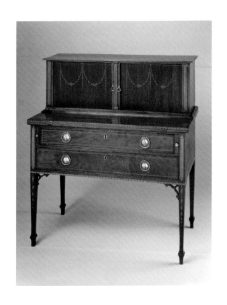

Fig. 17. Attributed to the shop of John and Thomas Seymour or Thomas Seymour's Boston Furniture Warehouse, Boston. **Tambour Desk.** *1794–1810. Mahogany and inlay; eastern white pine and red oak, 41 ⅛ x 37 ½ x 19 ½ in. (105.1 x 95.3 x 49.5 cm). The Bayou Bend Collection, gift of Miss Ima Hogg, B.65.12.*

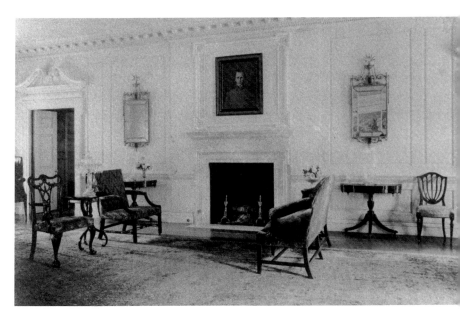

Fig. 18. The Drawing Room at Bayou Bend, c. 1930. At this time the room contained both Rococo and Neoclassical furniture.

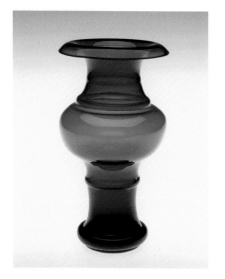

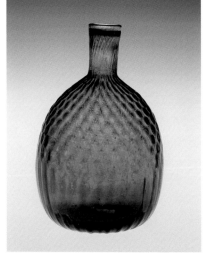

Fig. 19. *Unknown maker, New Jersey.* **Vase.**
1840–60. Emerald green lead glass, 6 ⅞ x 4 in.
(diam) (17.5 x 10.2 cm). The Bayou Bend
Collection, gift of Miss Ima Hogg, B.69.463.

Fig. 20. *Attributed to Glass Works of Henry William*
Stiegel, Manheim, Pennsylvania. **Pocket Bottle.**
Amethyst colored nonlead glass, 5 ⅛ x 3 ⅜ x 2 ⅞ in.
(13 x 8.6 x 7.3 cm). The Bayou Bend Collection,
gift of Miss Ima Hogg, B.58.13.

it is mid-nineteenth century (fig. 19). She preferred early examples, like this Stiegel
diamond-patterned pocket flask purchased from the noted scholar/dealer George
McKearin (fig. 20). At the end of the decade she was considering purchasing thirty-
eight pieces of Stiegel from Pennsylvania dealer William Montague. The earliest
known written reference to her collecting for a museum appears in a 1929 letter
from Montague discussing the potential purchase: "We realize, of course that there
is a strong possibility of your collection eventually finding its way to a Museum and
that any purchase you might make would possibly be kept intact for the future."[19]

It is from the summer of 1927 that we find the earliest documented purchased
of mid-nineteenth-century figured flasks with reference to the Mexican War, depict-
ing heroes like Zachary Taylor, Old Rough and Ready (fig. 21), and bearing slogans
such as "A Little More Grape Captain Bragg." For Miss Hogg, material pertaining
to the Mexican War, fought over Texas joining the United States, made an impor-
tant link between Texas history and that of the rest of America. She once described
Texas as an empire unto itself, geographically and historically remote from the rest
of the country.[20] During the ten years that I worked with her, she often referred

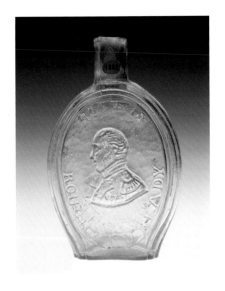

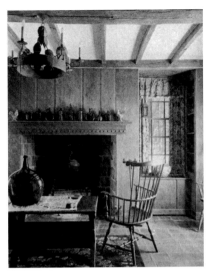

*Fig. 21. Probably Baltimore Glass Works, Maryland. **Figured Flask.** c. 1846. Aquamarine colored nonlead glass, 6 ⅞ x 4 ¼ x 2 ⅞ in. (17.5 x 10.8 x 7.3 cm). The Bayou Bend Collection, gift of Miss Ima Hogg, B.72.84.*

Fig. 22. The Game Room at Bayou Bend, 1930 (also called the Tap Room, now the Murphy Room). Examples of Miss Hogg's early glass are on display. The Museum of Fine Arts, Houston, Archives.

to Texas furniture, discovered late in her career, and American furniture as if they came from two different planets. As early as 1933, when the contents of Bayou Bend were inventoried, forty-three figured flasks were on display in the Game or Tap Room (fig. 22) (later remade into today's Murphy Room). During the early 1940s, this room came to be called the Texas Room. Thus in the context of the other Bayou Bend rooms with American furniture, this room represented an important historical link between America and Texas.

After the decision in the mid-1950s to turn her home and collection into a house museum, Miss Hogg's intent for Bayou Bend was that examples from colonial and Federal America were not meant to be only appreciated as aesthetic objects, but also to relate the history of our nation. That story was expanded in the early 1960s to include Texas, with the creation of a new Texas Room on the second floor (fig. 23). The Mexican War flasks were moved to the windows there, a collection of prints with Mexican War subject matter adorned the walls, and a large group of Staffordshire transfer-printed earthenware in a pattern called "Texian Campaigne" was assembled for the cupboards of the new room. She also collected

printed textiles with Mexican War themes and sheet music covers for Mexican War marches, expanding the theme that had begun with the figured flasks. These objects with Mexican War references were produced for a general American market, not for Texas, and indeed probably few, if any, found their way to Texas in the nineteenth century. As she did not yet know about nineteenth-century furniture made in Texas, she chose objects of southern origin from the second quarter of the nineteenth century, which she felt reflected the southern roots of many early Texas settlers, including that of her own family. Her rationale was that these represented the sort of things that they might have been brought with them when they trekked to Texas.

Ima Hogg's collecting of Americana virtually stopped in 1930, due in no small part to the death of her beloved older brother, Will, that same year. During the 1930s her collecting concentrated on Southwest Native American ceramics and twentieth-century European works on paper, including Picasso's *Three Women at the Fountain* (fig. 24). Additionally, she was deeply involved with the creation of the gardens at Bayou Bend: first with the conversion of the East Garden into a garden room, and then, at the end of the decade, with the Diana Garden on the slope north of the house (fig. 25). Her garden activity led her to a position on the board of the Garden Club of America, where she met Louise du Pont

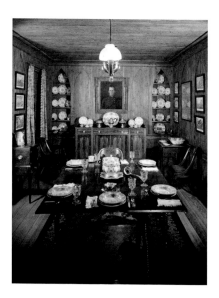

Fig. 23. The Texas Room at Bayou Bend, 1960s.

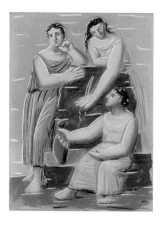

Fig. 24. Pablo Picasso. **Three Women at the Fountain**. 1921. Pastel on wove paper, 25 x 19 ⅛ in. (63.5 x 48.6 cm). The Museum of Fine Arts, Houston, gift of Miss Ima Hogg and other trustees of the Varner-Bayou Bend Heritage Fund, 69.2.

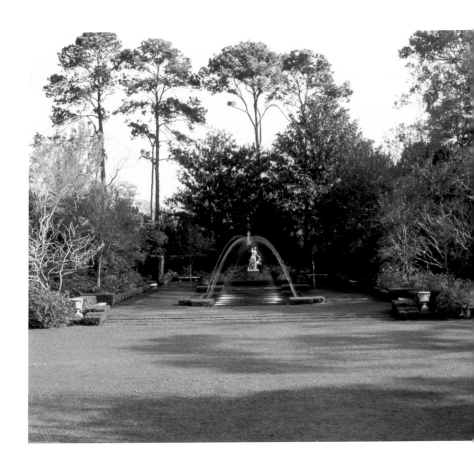

Fig. 25. The Diana Garden, Bayou Bend.

Crowninshield. Louise introduced Ima to her brother Henry Francis du Pont, known as Harry. In 1947, Ima made her first visit to Harry du Pont and his extraordinary collection at his Delaware home, Winterthur.

It was at about this same time that Ima Hogg's collecting of American furniture began to shift into high gear. During the next decade or so, a procession of extraordinary and rare masterpieces came from the East and entered the collection at Bayou Bend. Just to mention a few: a Massachusetts easy chair with its original show cover, one of only a few in existence (fig. 26); a Boston high chest, regarded today as having the most complete surviving example of japanning (fig. 27); the extraordinary Wharton family Philadelphia high chest (fig. 28), and a Newport

block-and-shell secretary, one of about a dozen known today (fig. 29). These acquisitions were important because they elevated the collection at Bayou Bend from a fine private holding, to a level of excellence that made it one of national importance, worthy of any museum is America. At this point Miss Hogg's transfer of American material culture to Texas assumed national significance.

Also at this time, her friendship and interaction with other major collectors became an important source of support and inspiration for Miss Hogg. Although she had met Harry du Pont earlier in the 1940s, it was not until the first Antiques Forum at Colonial Williamsburg in 1947 that she met other prominent collectors, including Electra Havemeyer Webb of Shelburne, Vermont; Maxim Karolik, benefactor of the Museum of Fine Arts, Boston; Henry and Helen Flynt, founders of Historic Deerfield in Massachusetts; and, most importantly, Katharine Prentis Murphy (fig. 30).

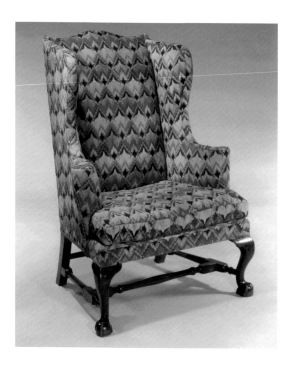

Fig. 26. Unknown maker, Eastern Massachusetts.
Easy Chair. *1750–1800. Mahogany; white pine and maple; and original wool needlework on linen canvas, 45 ½ x 32 ¼ x 31 ¾ in. (115.6 x 83.2 x 80.6 cm). The Bayou Bend Collection, gift of Miss Ima Hogg, B.60.89.*

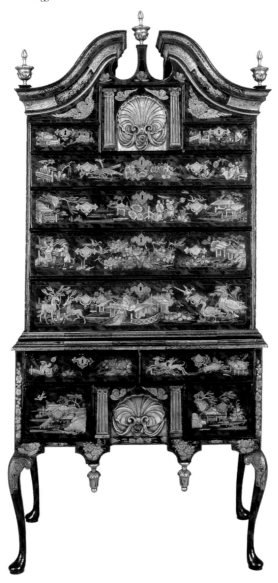

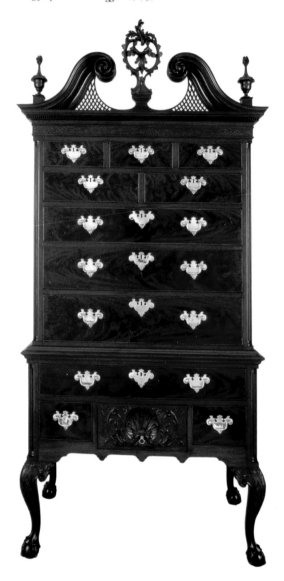

Fig. 28. Unknown maker, Philadelphia. **High Chest of Drawers.** *1760–1800. Mahogany and mahogany veneer; Atlantic white cedar, southern yellow pine, yellow poplar, 94 ⅜ x 46 ½ x 30 ⅜ in. (239.7 x 118.1 x 77.8 cm). The Bayou Bend Collection, gift of Miss Ima Hogg, B.69.75.*

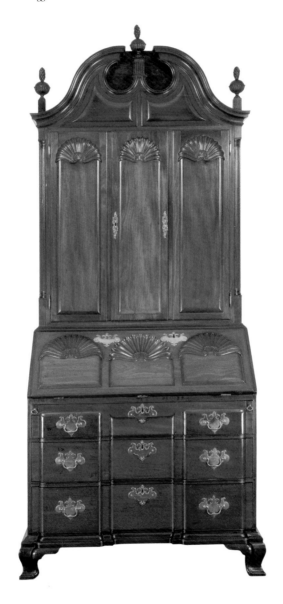

Fig. 29. Unknown maker, Newport. **Desk and Bookcase.** *1755–1800. Mahogany and secondary woods, 99 ¾ x 44 ¼ x 26 ¼ in. (253.4 x 112.4 x 66.7 cm). The Bayou Bend Collection, gift of Miss Ima Hogg, B.69.22.*

Katharine and Ima became very close friends, speaking on the phone every Sunday. These relationships made the distance between Texas and the East Coast seem not so very far. The group got together frequently to discuss antiques and what they were doing with their collections as they were brought into the public domain. Maxim Karolik called the them the "Antiquees" and deemed that they were kindred spirits.[21]

In March 1956 most of these collector friends came to Houston for a house party held in conjunction with an exhibition of Americana at the Museum of Fine Arts, Houston. Nearly all of the objects on view were from Miss Hogg's collection. Beginning in 1948 she had given eighteen major pieces of eighteenth-century furniture to the museum, although they physically remained at Bayou Bend. Among them were iconic pieces from the Bayou Bend Collection, such as the John Townsend bureau table (fig. 31). Ruth and Harry du Pont also came to Houston for the house party. The main topic of conversation among the "Antiquees" was how Ima Hogg would ultimately place her collection. One obvious alternative was giving it to a museum, in this case the Museum of Fine Arts, Houston, with the objects to be displayed in a conventional gallery setting. Another thought was to leave it in Bayou Bend and make a "house museum," to use a term coined by Harry du Pont. During his 1956 visit to Bayou Bend, he strongly encouraged Miss Hogg to leave her collection in her house just as he had done at his house, Winterthur, a few years earlier.[22] That is exactly what she did the following year, with the gift of Bayou Bend to the Museum of Fine Arts, Houston, to be used as a house museum showcasing her collection.

That decision was to have a profound effect on the type of American material culture Ima Hogg would bring to Texas. When Bayou Bend was simply a home furnished with fine American antiques, Miss Hogg concentrated on furniture and arranged her pieces according to her personal preferences and convenience. But to make proper museum period settings for the collection, she would have to expand the collection into other areas, including metals, silver, pewter, ceramics, and—most notably—paintings.

Her first acquisitions of American paintings had actually taken place a few years earlier. In late 1953, New York dealer Norman Hirschl wrote her that he had learned from Maxim Karolik that she wanted to form a collection of American colonial paintings. Her response, relayed through Lee Malone, director of the Museum of Fine Arts, Houston, stated, "As you know from our past conversations,

*Fig. 30. Ima Hogg (left) with Bayou Bend architect
John Staub and fellow collector Katharine Prentis
Murphy at the dedication of the Murphy Room
at Bayou Bend, 1959. The Museum of Fine Arts,
Houston, Archives.*

it is not my intention to make a representative collection of American portraits,
as surmised by Mr. Karolik. I hope somebody else will, but in the meantime if
the right opportunity presents itself I would add a few."[23] Indeed, she had already
bought from Hirschl and Adler a wonderful portrait, *John Gerry* by Joseph Badger,
and this perhaps is what engendered Mr. Karolik's idea. Despite her claim that she
might buy a only a few paintings, in the next year she acquired major works for
the collection, including John Singleton Copley's early *Portrait of a Boy* (see fig. 45)
and late New York *Portrait of Mrs. Paul Richard* (fig. 32), two Copley pastels and
five drawings; and if that were not enough, John Wollaston's *William Holmes*, a
Charleston subject, and Edward Hicks's *Peaceable Kingdom*. And she continued
to pursue the very finest.

In 1960, Rudolph Wunderlich, owner of New York's Kennedy Gallery, offered her a self-portrait of Charles Willson Peale that includes portrayals of his wife, Rachel, and daughter Angelica Kauffmann Peale (illustrated on page 47). Wunderlich traveled to Houston with the painting and brought it to Bayou Bend. Picasso's *Head of a Woman*, which hung in the Drawing Room, was taken down and the Peale hung in its stead. Wunderlich stayed as a guest for dinner. Ima Hogg loved the painting but it was extremely expensive, more than she felt she could afford, so she reluctantly told Wunderlich to take it back with him to his hotel. She later recounted that she was not able to sleep that night, thinking about the picture. She agonized whether she would ever have the opportunity to get another Peale self-portrait. So as the sun came up, she determined she was going to have it and would somehow make the financial stretch to do so. She called the dealer at his hotel early the following morning to tell him to bring it back, only to discover he had already left for the train station. He was intercepted and the superb painting became part of the Bayou Bend Collection.

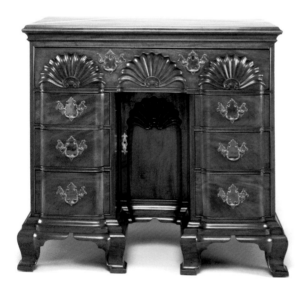

*Fig. 31. Attributed to the shop of John Townsend, Newport. **Bureau Table.** 1785–1800. Mahogany; chestnut and yellow poplar, 34 ½ x 39 ¼ x 22 in. (87.6 x 99.7 x 55.9 cm). The Bayou Bend Collection, gift of Miss Ima Hogg, B.69.91.*

As Miss Hogg's collecting progressed and became more focused in the 1950s and 1960s, she made detailed lists of desiderata. A high priority on her painting list was an example by Robert Feke. A decade after the Peale purchase she was offered a pair of modest bust-length portraits of Rev. and Mrs. Gershom Flagg. Although she was excited about the chance to obtain works by Feke, she realized that these were not really up to the standards of excellence she had set for her collection. At her direction I wrote the dealer, Robert Vose, sending back the Flagg portraits and conveying to him that what Miss Hogg really wanted was an elegant three-quarter-length example like the Bowdoin family portraits, now at the Bowdoin College Museum of Art. Vose responded that he knew of such an example that was not for sale, but the owner would not be offended if Miss Hogg wrote a letter indicating her interest. It turned out to be a slightly earlier Philadelphia portrait whose subject had recently been identified as Mrs. Samuel (Anne) McCall, Jr. (fig. 33). A complicated series of negotiations ensued, and finally a price was set. Miss Hogg was floored because it was $125,000—roughly $60,000 more than she had ever

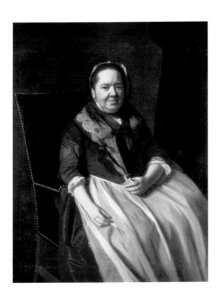

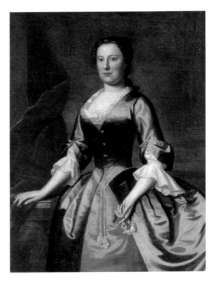

Fig. 32. John Singleton Copley. **Portrait of Mrs. Paul Richard.** *1771. Oil on canvas, 50 x 39 ½ in. (127 x 100.3 cm). The Bayou Bend Collection, gift of Miss Ima Hogg, B.54.18.*

Fig. 33. Robert Feke. **Portrait of Mrs. Samuel McCall, Sr.** *1746. Oil on canvas, 49 ⅞ x 39 ⅞ in. (126.7 x 101.3 cm). The Bayou Bend Collection, gift of Miss Ima Hogg, B.71.81.*

spent on art, and she was unsure how she would afford the asking price. Yet she was determined to have the 1746 portrait of Anne McCall. She began to think about the two Picasso gouaches that she had bought in Paris in 1929. As much as she loved them, they did not fit into her current mission. So she made arrangements to sell them. In the end, only *Head of a Woman* was sold, to Norton Simon; the other, *Three Women at the Fountain* (see fig. 24), she eventually gave to the MFAH.

Today the collection of American painting at Bayou Bend, while small, is of a caliber as high as that of the furniture. Although she initially set out to collect only a few paintings, over the years she amassed a comprehensive body, and in the case of these two examples, at considerable sacrifice. Her transfer to Texas in this area of American material culture was extraordinary.

At about the same time, Ima Hogg was broadening her collecting by entering into the realm of American paintings, she also began to add examples of colonial American silver. In this area, too, she made some extraordinary acquisitions. Included were an early Boston tankard by Jeremiah Dummer, America's first native-born silversmith (fig. 34). She also acquired an exquisite Rococo cream pot was made in Boston by Jacob Hurd (fig. 35). Again, she had her wish lists, which led her to the addition of rare forms such as a New York two-handled bowl by Cornelius Kierstede (fig. 36).

Fig. 34. Shop of Jeremiah Dummer, Boston.
Tankard. *c. 1695–1710. Silver, 6 ½ x 5 ⅛ x 8 ¼ in. (16.5 x 13 x 21 cm). The Bayou Bend Collection, gift of Miss Ima Hogg, B.69.115.*

Fig. 35. Shop of Jacob Hurd, Boston.
Cream Pot. *1745–c. 1755. Silver, 4 1/16 x 2 1/2 x*
3 1/2 in. (10.3 x 6.4 x 8.9 cm). The Bayou Bend
Collection, gift of Miss Ima Hogg, B.69.112.

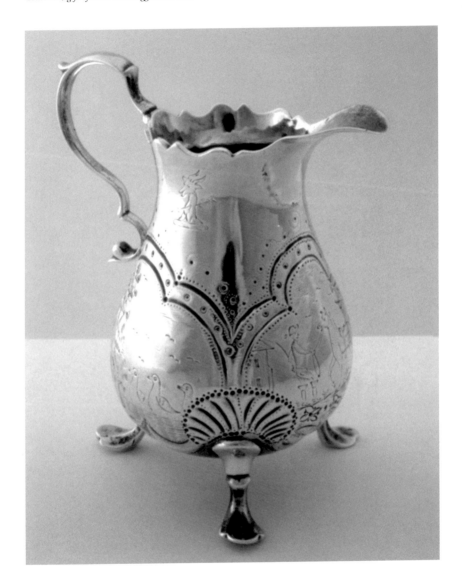

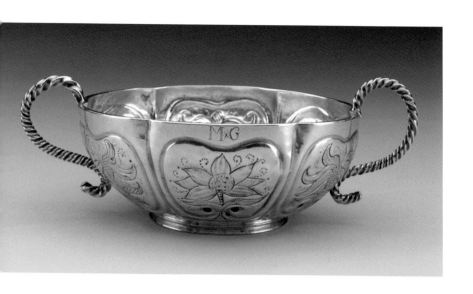

Fig. 36. Shop of Cornelius Kierstede, New York.
Two-handled Bowl. 1696–1731. Silver, 2 5/16 x
6 5/16 x 4 3/8 in. (5.6 x 16 x 11.1 cm). The Bayou
Bend Collection, gift of Miss Ima Hogg, B.63.3.

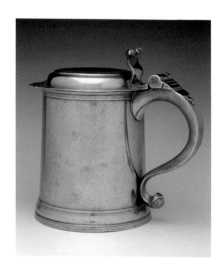

Fig. 37. Shop of Frederick Bassett, New York
and Hartford. **Tankard.** 1761–99. Pewter,
6 7/8 x 5 3/8 x 7 3/8 in. (17.5 x 13.7 x 18.7 cm).
The Bayou Bend Collection, gift of Miss Ima Hogg,
B.60.55.

*Fig. 38. Shop of Peter Young, New York and Albany. **Church Cup (one of a pair).** 1775–97. Pewter, 8 7/16 x 4 7/16 in. diameter (21.5 x 11.3 cm). The Bayou Bend Collection, gift of Miss Ima Hogg, B.66.9.1.*

A little later she began to acquire pewter. As with her silver collecting, she selected the rarest and the best examples, including an early New York tankard by Frederick Bassett (fig. 37) and later a rare pair of Albany, New York, chalices by Peter Young (fig. 38), bought after Bayou Bend had opened to the public in 1966.

In terms of American ceramics, Ima Hogg had purchased a small body of Tucker porcelain in 1922, including a group of the distinctively Tucker vase-shaped pitchers and an extremely rare pair of fruit baskets (fig. 39). In the early 1970s she was thrilled to be able to acquire a rare pair of polychrome vases (fig. 40)—a form new to the collection—which came with the extra dividend of a provenance from the artist James Peale, who was represented in the collection by a landscape painting. However, while the provenance or history of an object was always of great interest to Ima Hogg, in the end it was the aesthetic quality of the piece rather than the antiquarian interest that was for her the determining factor.

In the area of pottery, she was enamored with mid-eighteenth-century English earthenwares—Whielden, salt glaze, and tin glaze, and again she bought the finest. In the late 1950s she began to collect the mottled brown, flint enamel-glazed

wares, generically called Rockingham and made in various American East Coast
cities, including a Toby jug made by the Lyman Fenton firm in Bennington,
Vermont, and a rare teapot made in Baltimore by E. and W. Bennett depicting
Rachel at Jacob's well. The tradition of southern alkaline glazed wares and the
products of the Edgefield, South Carolina, area were unknown to her until 1974,
when at the age of 92 she encountered two examples in the shop of a Houston
dealer—one from the Thomas Chandler pottery, the other from either the
Pottersville or Miles pottery. She did not know their details, but their beauty com-
pelled her to buy them. Nor did she know that the tradition of this sort of pottery
spread across the south and was influential in Texas, as is related in Jill Beute
Koverman's essay in this volume. How she would have loved that connection.

In December 1964, I came to Texas to be interviewed for the position of
Curator at Bayou Bend. Miss Hogg was still in residence. During the several days
at Bayou Bend, I had the opportunity to discuss the future direction of the collec-
tion with Miss Hogg. One goal was to add a room of Belter furniture. "I think

Belter is very important, don't you?" she said. "Belter," I thought to myself,
"what in the world is that?" My exposure in the East Coast and at Winterthur
did not include that area of expertise. "Er, yes, I agree," I said, hoping and praying
she would not ask me anything more about Belter. In any event, I was hired, and
a room with Rococo Revival furniture by John Henry Belter was in our future.
Before that happened, though, the Empire style intervened. The world of Americana
had been stunned by Berry Tracy's groundbreaking 1963 exhibit at the Newark
Museum, *Classical America.* I, as a new Winterthur graduate, had the temerity
to suggest that a room of Empire furniture should come first before one of Belter.
The style was not unknown to Ima Hogg, both from exposure growing up to
antebellum furniture and more recently from purchases made to furnish her
restoration of Varner Plantation during the 1950s. Where I grew up, in Wilmington,
Delaware, most people laughed at the Empire style or thought it was grotesque.
Not Ima Hogg, who embraced the idea and in no time had acquired some
superb examples.

Before the Empire rooms were finished, some of the new pieces were stored temporarily in the kitchen at Bayou Bend. Miss Hogg was eager to show them to Katharine Murphy. In the spring of 1967 Mrs. Murphy was back in Texas for the dedication of Miss Hogg's restoration at Winedale. Ima took her to the kitchen to see her newest prizes, a New York sideboard (fig. 41) and a Philadelphia center table. "Oh, Ima," Mrs. Murphy trilled, "if I thought Empire furniture looked like that, I would like it!" In this interchange, not only was Ima Hogg once again transferring American material culture to Texas but also was expanding the mind of an easterner who only collected early eighteenth century objects. The new rooms of Empire furnishings, dubbed the Chillman Suite (fig. 42), were located in an area that had formerly been part of the service wing. No sooner were they completed that work on the Belter Parlor began.

Fig. 41. Attributed to the Shop of Joseph Meeks & Son, New York. Sideboard. 1825–35. Gilded mahogany; mahogany veneer, white oak, soft maple, ash, eastern white pine, and yellow poplar, 60 ¼ x 68 ½ x 28 in. (153 x 174 x 71.1 cm). The Bayou Bend Collection, gift of Mrs. Harry C. Hanszen, B.67.6.

Fig. 42. The Chillman Parlor, Bayou Bend.

Fig. 43. The Blue Room (now the Massachusetts Room),
late 1940s, with Miss Hogg's Rococo Revival furniture.
The Museum of Fine Arts, Houston, Archives.

Fig. 44. The Belter Parlor, Bayou Bend.

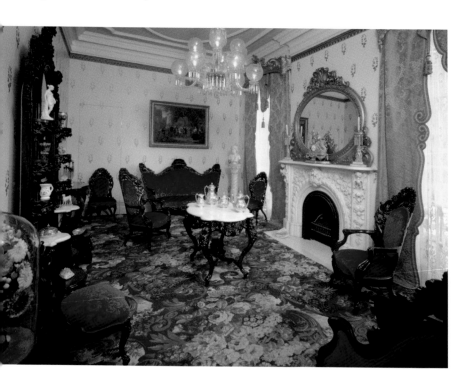

Ima Hogg had purchased a small Rococo Revival parlor suite in 1944, which for some years was installed in the Blue Room (now called the Massachusetts Room) at Bayou Bend (fig. 43). For some reason, a Belter side chair ended up in my office sometime around 1967. As I have already confessed, I knew nothing about Belter. However, having the chair in my space and seeing it every day, I came to have both an appreciation and an affection for the chair and for the Rococo Revival style. When the Belter Parlor, was finished in the spring of 1971 (fig. 44), Miss Hogg had a little dinner at Bayou Bend honoring Charles and Florence Montgomery. Montgomery, recently retired as director of Winterthur, had been a mentor to Miss Hogg, advising her in the transition of Bayou Bend from a home to a house museum and recommending accessions. I vividly remember Ima Hogg and Charles Montgomery seated on the sofa of the parlor suite. "Now Charles," she said, "look at that carving. It's just as good as Chippendale, don't you think?" The look on Montgomery's face spoke volumes, but he politely, albeit

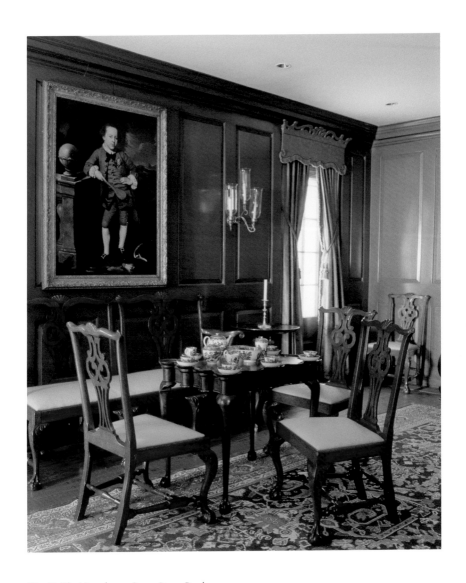

Fig. 45. The Massachusetts Room, Bayou Bend.

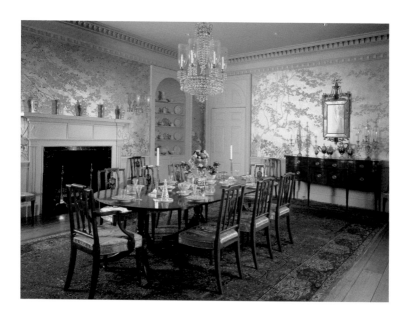

Fig. 46. The Dining Room, Bayou Bend.

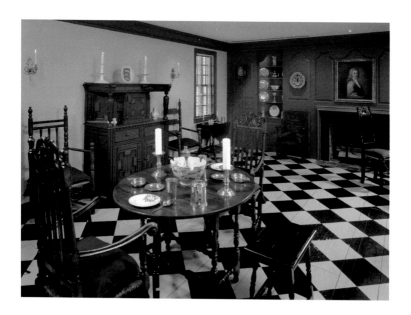

Fig. 47. The Murphy Room, Bayou Bend.

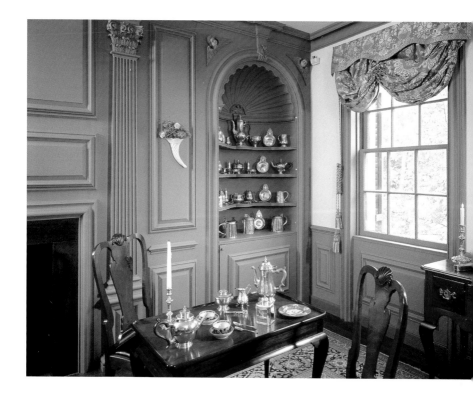

Fig. 48. The Newport Room, Bayou Bend.

noncommittally, responded, "Yes, it's very interesting." Fascinatingly, a year or two afterward, he had left Winterthur and had begun teaching at Yale, where he wildly embraced all elements of the nineteenth century. However, at that point at Bayou Bend, the student, Ima Hogg, had become the teacher; the Texan was transferring material culture to the easterner.

With the decision to leave the collection in the house came the Miss Hogg's realization by that there would have to be major changes to create an installation that would make the collection a teaching tool. Some rooms had always been fairly coherent in the style installed there, such as the Drawing Room with its Chippendale or Rococo furniture, or the Music Room with its Neoclassical examples. In other cases, it meant simply moving furniture from one room to another—for example, taking the Belter furniture out of the Blue Room and installing the suite of Massachusetts Chippendale furniture to transform it into the Massachusetts

Room (fig. 45). Conversely, Neoclassical furniture was installed in the Dining Room, reflecting the emergence of the dining room in Federal American interiors (fig. 46). Additionally, whole new rooms were created to make period settings. First, the Murphy Room was created as a setting for the earliest seventeenth- and early eighteenth-century pieces, with new woodwork based on a Connecticut interior given by Katharine Murphy to the New Hampshire Historical Society (fig. 47). Woodwork based on Newport's Hunter house was installed on the second floor to make a setting for Newport furniture (fig. 48). Miss Hogg's own bedroom suite became devoted to the mid-eighteenth-century Queen Anne style. Miss Hogg created the Texas Room to make the American material culture transferred to Bayou Bend more readily accessible to the Texans and others who would visit the house museum.

One of Ima Hogg's less obvious but supremely important contributions was the establishment of a group of volunteer docents, which made Bayou Bend and its collection of Americana a vital part of the cultural fabric of Houston. Miss Hogg was a great believer in volunteerism, and her powers of persuasion were legendary. The group, organized in 1960 with women hand-picked by Miss Hogg, was initially trained by Jonathan Fairbanks, who was lent to Bayou Bend by Winterthur, where he was a young curator. This cadre of women, and now some men, became a crucial force in interpreting the Americana at Bayou Bend making it accessible to the visiting public, Houstonians, Texans, and denizens of the Gulf Coast and American Southwest. Over the ensuing decades, the Bayou Bend Docent Organization has thrived and evolved into a devoted, knowledgeable group; some of them are collectors themselves, and they represent a valuable pool of Houstonians with a sophisticated and broad knowledge of early Americana.

Miss Hogg's determination to constantly improve her collection of Americana did not wane as she grew older (fig. 49). On her wish-list of paintings was a work by the Connecticut artist Ralph Earl. In the early summer of 1975, aged 93, she set off for a trip London and ultimately to Bayreuth to hear Richard Wagner's *Ring* cycle. She began her journey with a side trip to Boston to see Earl's portrait of Dr. Mason Fitch Cogswell at the Vose Gallery. She decided to buy it and asked the gallery to hold it until her return. Alas, she was injured getting into a London cab following a shopping spree at Harrods, and died quietly in her sleep a few days later. However, her quest to bring the Earl portrait to Texas was accomplished when the painting was bought for Bayou Bend by the Museum of Fine Arts, Houston.

Fig. 49. Miss Ima Hogg at age 91, 1973.

In March 1966 Bayou Bend was officially dedicated and opened to the public. In Miss Hogg's remarks to those assembled for the occasion, she conveyed several interesting and seminal thoughts. "While I shall always love Bayou Bend," she said, "and everything there, in one sense I have always considered I was only holding my collection in trust for its transition."[24] Thus her quest and her gift to Texas were acknowledged, and at the same her incredible generosity revealed. She also said, "I hope in a modest way Bayou Bend may serve as a bridge to bring us closer to the heart of an American heritage which unites us." [25] Today that hope has certainly been accomplished, and not in a modest way. Without her, and her extraordinary sense of purpose, Houston would likely be like the rest of Texas, not a factor for those devoted to American material culture. I thank her, and I am confident that all those who have participated in this symposium thank her, too. The torch she gave us burns bright.

Notes

1 These words were spoken at the Bayou Bend Dedication Ceremony, March 6, 1966, and repeated in Miss Hogg's foreword to the first Bayou Bend catalogue; see Ima Hogg, foreword to *Bayou Bend: American Furniture, Paintings and Silver from the Bayou Bend Collection*, by David B. Warren (Houston: The Museum of Fine Arts, Houston; Boston: New York Graphic Society, 1975), vii.

2 Ibid., vii.

3 Jean Houston Daniel, Price Daniel, and Dorothy Blodgett, *The Texas Governor's Mansion and History of the House and Its Occupants* (Austin: State Library and Archives Commission and the Sam Houston Regional Library and Research Center, 1984), 320–21.

4 Ima Hogg typescript manuscript of reminiscences, c. 1944, Ima Hogg Papers, Center for American History, The University of Texas at Austin.

5 Ima Hogg to Sarah Stinson Hogg, July 1, 1894, Ima Hogg Papers.

6 John Lomax, *Will Hogg, Texan* (Austin: University of Texas Press, 1956), 6.

7 Ima Hogg to Will Hogg, January 27, 1921, William C. Hogg Papers, Center for American History, The University of Texas at Austin.

8 Hogg, foreword to Warren, Bayou Bend, vii.

9 Howard Barnstone, *The Architecture of John F. Staub Houston and the South* (Austin: University of Texas Press, 1979), 77.

10 Inventory, 1933, Ima Hogg Papers.

11 Charles O. Cornelius, "Transplanting the Eastern Tradition: The Residence of Mrs. John F. Staub, in Houston, Texas of Which John F. Staub was the Architect," *The House Beautiful* 62 (January 1928): 24–28.

12 Ima Hogg to Dorothy (an unidentified friend), February 8, 1926, Ima Hogg Papers.

13 Ima Hogg to Marie (Mrs. Thomas E.) Hogg, February 8, 1926, Ima Hogg Papers.

14 Staub owned a full run of the White Pine Series of Architectural Monographs, which were published between 1915 and 1931 by the New England lumber industry and contained detailed scale drawings of colonial American woodwork. His copies were donated to the Bayou Bend Library in the late 1960s.

15 Recently the paneling of the Metcalf Bowler Room was deinstalled from the American Wing. The Metropolitan Museum generously made the woodwork available to Bayou Bend for a nominal price, and it has been transferred to Houston, where it will be installed in the new Bayou Bend Visitors Center, now in the planning stages.

16 Ima Hogg to Lyman Armes, April 30, 1927, William C. Hogg Papers.

17 Information on the summer visit with the Blaffers and meeting Sleeper is from the author's interview with Jane Blaffer Owen, their daughter, October 6, 2006.

18 American Art Association, New York, November 17, 1923.

19 William B. Montague to Ima Hogg, June 18, 1929, Bayou Bend Collection and Gardens Records, the Museum of Fine Arts, Houston, Archives.

20 Hogg, foreword to Warren, *Bayou Bend*, viii.

21 Maxim Karolik to Ima Hogg, July 11, 1957, Bayou Bend Collection and Gardens Records, the Museum of Fine Arts, Houston, Archives.

22 Henry Francis du Pont to David Warren, February 11, 1966, Winterthur Archives, Delaware.

23 Norman Hirschl to Ima Hogg, October 21, 1953; Ima Hogg to Lee Malone, November 3, 1953, Bayou Bend Collection and Gardens Records, the Museum of Fine Arts, Houston, Archives.

24 Hogg, foreword to Warren, *Bayou Bend*, viii.

25 Ibid.

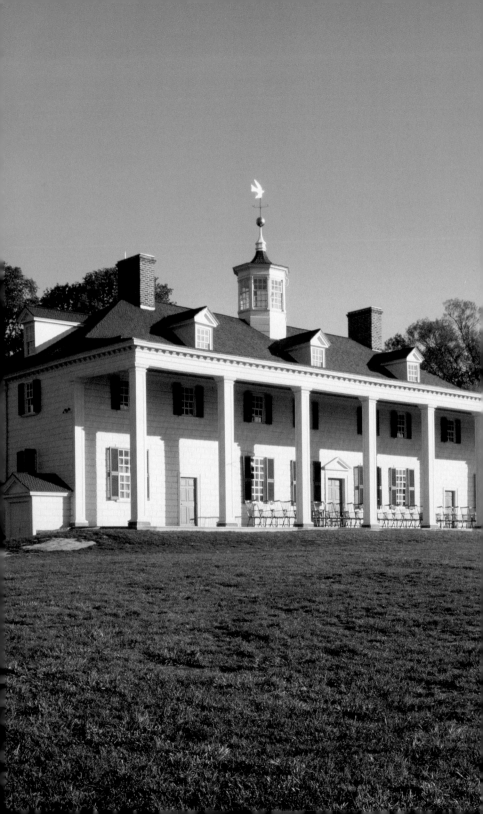

American Material Culture:
Artists, Artisans, Scholars, and a World of Things

Margaretta M. Lovell

How useful is the term "American material culture"? What does it imply in terms
of method, theory, and subject? This essay broaches these questions and argues
for the usefulness of this term—imported from anthropology and the social
sciences—and for the concepts it has come to embody for scholars of American
art, architecture, vernacular objects, and design, in short, for those who study
objects made in what is now the United States.

Material culture is a larger category than "decorative arts" or "art"; it is more
flexible and less exclusionary than either of those terms. It has more authority than
"things," although recently we have been hearing about "thing theory."[1] In terms of
subject, material culture embraces everything fabricated or manipulated by human
intention.[2] In terms of method, material culture studies build arguments about the
human past and present from physical objects that one can see, touch, and some-
times heft, or smell, or kick. It involves an epistemology based on the five senses.

What, one might ask, is the usefulness of a term that embraces both junk
and art, assemblages of roadside discards and the precious furnishings of a grand
eighteenth-century house? In what ways can one method usefully be applied to
common mass-marketed things and the exceptionally rare products of ingenious
manipulation of precious materials like silver and mahogany? The question this
essay asks is exactly that: is it useful to think of these things in the same breath?

Detail, fig. 7

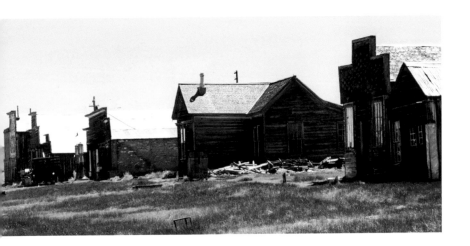

Beginning with definitions, this essay will discuss the history of thinking about (and exhibiting) American objects, assemblages, artworks, and things; I will then turn to how scholars, curators, collectors, and museum-goers arrived at the present when an important symposium is titled "American Material Culture and the Texas Experience," a collection of words that might not have been comprehensible to museum benefactors or audiences in the last century. Each generation adds to the terms, values, and knowledge systems of its predecessors. This shifting, accumulative, generational object-thinking is a subject of cultural inquiry of extraordinary richness.

Material culture includes things of all scales, from things you can put in your pocket, such as coins, to monuments visible for miles, like Eero Saarinen's arch in St. Louis, dedicated in 1968. It includes decorative arts objects (household furnishings, both grand and modest), whole houses, groups of buildings around farmyards and mine shafts, and whole cities, such as Bodie, California, now a ghost town and one of the most magical places in America to look the past in the face (fig. 1). It includes engineering projects such as the Golden Gate Bridge in San Francisco and Central Park in New York City. It includes photographs and paintings, such as the enigmatic late-eighteenth-century family portrait by Charles Willson Peale now in the Bayou Bend Collection (fig. 2).[3]

Fig. 2. Charles Willson Peale. **Self-Portrait with Angelica and Portrait of Rachel Peale.** *c. 1782–85. Oil on canvas, 36 ⅛ x 27 ⅛ in. (91.8 x 68.9 cm). The Bayou Bend Collection, gift of Miss Ima Hogg, B.60.49.*

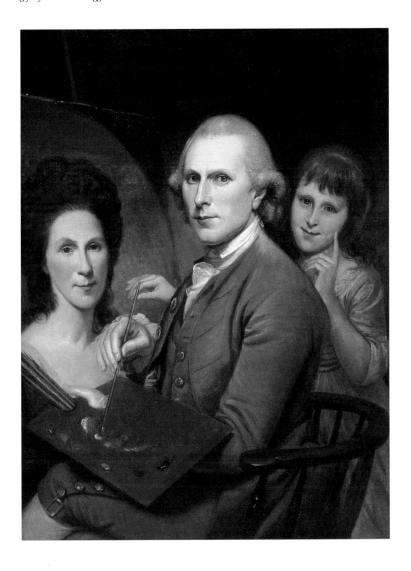

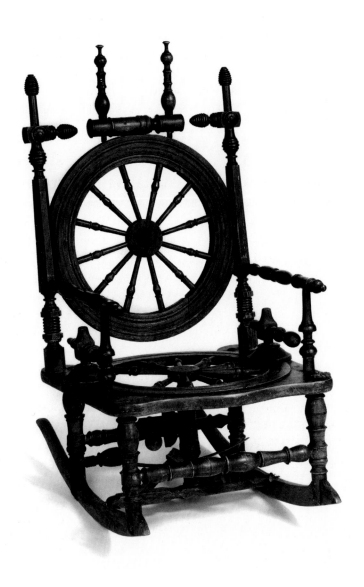

Fig. 3. Unknown American. **Armchair**
(Spinning Wheel Chair). *c. 1880. Maple,*
ash, and pine (made from old spinning wheels).
Worcester Art Museum, Worcester, Massachusetts,
gift of Christopher Monkhouse.

Material culture includes objects, such as eighteenth-century spinning wheels, made into other objects, such as nineteenth-century spinning-wheel rocking chairs for a generation that wanted to *think* about spinning wheels as symbols of female industry and virtue, but did not want to spin (fig. 3).[4] The term "material culture" in this new guise refers not just to the assemblages or object-worlds associated with the social culture of a distinct human group—understood in functionalist terms as in its anthropological context—rather, it expands to resonate with all subsequent cultures and their object-based ideological constructions.

Material culture also includes natural objects—such as the horns of steers—made into fabricated objects, as in a longhorn chair made in San Antonio c. 1885–95, now educating Texans about longhorn steers, ingenious chairs, and jaguar pelts (fig. 4). In fact, nature is a major category of material culture, for it includes crops engineered over centuries, indeed millennia, by resourceful farmers. Carefully selected, planted, pruned, irrigated, fertilized, and harvested, New World plants—corn, potatoes, and chocolate, for instance, even before recombinant DNA projects— were husbanded in every way to produce designed and intended human products.

Nature is also material culture when it is a clear-cut mountainside or a trophy head on a hunter's wall, or when it is left "natural" but incorporated into an architectural context, such as an allée of trees or Adirondack furniture. In the case of Oak Alley in Louisiana, the trees are organized to draw the eye to a house; they are natural but they are arranged orthogonally, and, as such, are evidence of a will to order even though the trees are not pollarded or otherwise individually manipulated (fig. 5). In the case of the Adirondack chairs, tables, and desks, these tree-in-the-living-room furnishings are intended to wittily reference the wilderness environment of the baronial camps of upstate New York, muting the distinction between inside and outside by the unmilled quality of the trees and branches incorporated into this rustic furniture from the turn of the twentieth century. These are evidence, in other words, of distinct and different attitudes toward nature and toward culture—one majestic, the other witty; the one an agent of patriarchy, the other an expression of anti-urbanism.

The difference between the larger category of material culture (including art) and art as it is usually understood, in this argument, is that the former is both an object of the aesthetic gaze *and* evidence in an argument about social experience.[5] Generally speaking, an art historian looks at the culture in which an object was made to learn more about the object; the material culturalist looks at the object(s) to learn more about the culture. An object or an assemblage in a material culture

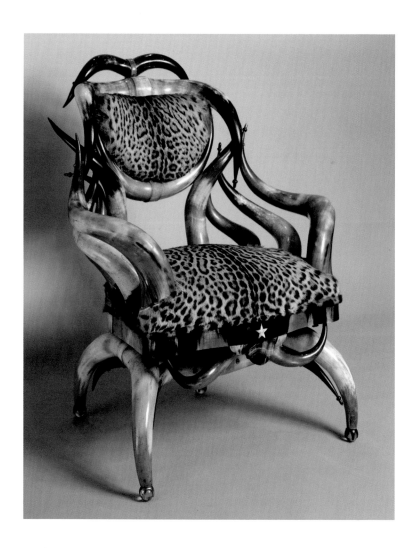

Fig. 4. Attributed to Wenzel Friedrich,
San Antonio, Texas. **Spring Rocking Chair.**
c. 1885–95. Steer horn, horn veneer, jaguar hide,
iron, chrome-plated iron, and wood, 37 ½ x 30 ½ x
31 in. (95.3 x 77.5 x 78.7 cm). The Museum of
Fine Arts, Houston, gift of William J. Hill, 83.138.

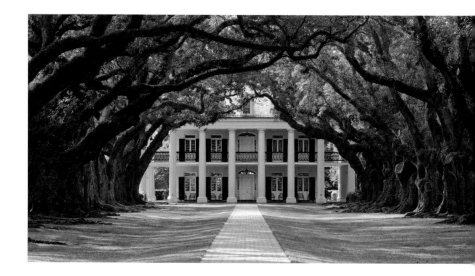

context can tell us about more than itself; it can tell us about the attitudes and assumptions of its makers—attitudes about people, about nature, about hierarchy, about time, about modernism, about different kinds of power, even about the absence of power. It can tell us things about which the written record is silent or misleading. Material culture has no inherent hierarchy of value except its value to tell us about its makers, because the questions material culture studies seek to answer are about people, not things, about what the community knew, what it valued, how it went about its business of daily life.[6] The designing, making, buying, shipping, hanging, and survival of portraits, for instance, tells us they were important, sought, enjoyed, closely observed, and handed down. Painted portraits, like the Peale family group (see fig. 2), are a form of communication we no longer understand; so when we look at them we must exert ourselves to recapture and comprehend their messages.[7] The many colonial desks with specialized interior spaces that survive from the eighteenth century tell us that it was a credit economy, one that required quantities of paper and record-keeping, one that valued and *displayed* its record-keeping. Similarly, the many chests of drawers from that time point to a sudden amplitude of textiles, and, more important, to a desire to sort and organize those clothes and linens.[8] To make those desks and chests, the craftsmen

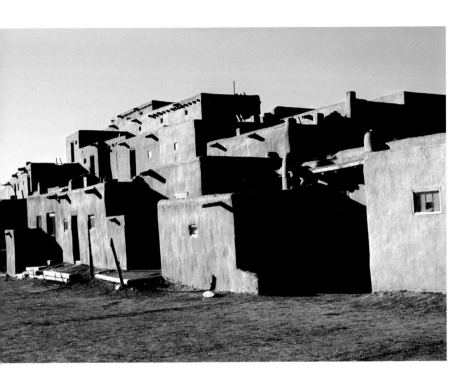

Fig. 6. Taos Pueblo, New Mexico, pre-seventeenth century.

and their patrons, sitting on the edge of seemingly limitless hardwood forests, went to extraordinary expense and risk to procure mahogany from the Caribbean.[9] What optical qualities, what engineering capabilities were they after? Material culture scholars seek to know about such choices, such materials—what is the difference, for instance, in terms of strength, grain, and carve-ability between mahogany and the much handier walnut? And what are the social differences? Did the Philadelphia Quakers opt for walnut because they preferred its look or because its local origin carried a different ideological message than the internationally embroiled mahogany?

Scholars of material culture also exert themselves to know how things were fabricated, not so they can better detect fakes (although that is one outcome), but so they can know about available technologies and about the processes of design, production, distribution, use, and disposal. They also seek to understand the nature of the workshop unit: how many men (or women) did it employ and support? How long did it take a youngster to learn those techniques for manipulating those

materials? How was he or she taught? Was inventiveness or replication encouraged? Where and how were the materials acquired? Objects are evidence of decisions about how individuals and communities spend their time, energies, and resources; in other words, objects are evidence of what people value. The material culturalist seeks to ferret out those decisions and the social, technical, material, economic, and aesthetic factors that went into those decisions.[10]

The history of the survival of old things is also a history of valuing old things, and of learning to value old things. Many old things, such as the buildings at Taos Pueblo, New Mexico, survived into the modern era primarily because they had use value (fig. 6). They could be fixed and repaired, and as long as the culture using them did not value novelty and did not have more profitable uses for the land and capital to put those ideas into motion, they survived. Survival is different from preservation. Preservation requires a shift in thinking to a different kind of use value: abstract concepts come into play and exert pressure on thinking and on action. We will begin our discussion of the ways material culture objects have been valued by their users and by the public, and the ways they have been studied by scholars, with preservation.

Preservation is a relatively modern concept, one we usually date, at least in its more formal dimensions in Europe and America, to the middle of the nineteenth century with campaigns to set aside and "freeze" in time certain structures and places.[11] Characteristic is the project, conceived in 1853 by Ann Pamela Cunningham, to establish the Mount Vernon Ladies' Association to buy and protect the home of George Washington (fig. 7). As in the case of other objects of its type, the public was not interested in preserving and visiting the building because it was an unusual example of revisions to a 1730s vernacular Georgian farmhouse, or because it sports a curious, or even beautiful, example of a vernacular Greek Revival portico, but because Washington slept there. Neither building type nor style were motivating factors; instead, it was contact with a memorable individual of high achievement that triggered the extraction of the site from private ownership (Washington heirs) and the vicissitudes of time, and led to its reinvention as an unchanging public resource.[12]

Olana, a house and picturesque estate on the banks of the Hudson River, similarly survived intact—more intact than Mount Vernon—because of the veneration of descendants and then of professional historians for the paintings of its designer and owner, the artist Frederic Edwin Church.[13] Admiration for the political, military, and aesthetic achievements of singular individuals was the first strong motive for preservation, and it has saved us some great treasures.

At the 1876 Centennial in Philadelphia an exhibition called *The New England Kitchen*, which incorporated and quoted elements of seventeenth-century New England interiors such as a massive fireplace, a heavy beamed ceiling, and heirloom furniture, gave popular impetus to a new phenomenon: the period room (fig. 8).[14] This innovation tied the furnished architectural interior less to a specific public figure than to general concepts of habitation and virtue among ordinary people. Today, our "great rooms" with their timber ceilings and our living rooms with their wood-burning fireplaces remember this 1876 turn to historic building and heating systems, marking the middle-class home over the last century and a half as a site of archaic, even regressive technology and ideology. The broader idea introduced at the Centennial, when translated to museum practice, was to install period rooms—authentic elements of buildings and furnishings—to create galleries that would prompt a visitor to imaginatively reinhabit a typical room of a culture from another place or time. This enthusiasm for the period room gained general currency in the years following the Centennial, public prominence with the opening of the American Wing at the Metropolitan Museum in New York in 1924, and reached its apogee with the opening of the Henry Francis du Pont Winterthur Museum in Delaware, in 1951 where more than a hundred furnished period rooms can be visited. The idea behind the period room and *The New England Kitchen* was not to celebrate singular men as at Mount Vernon but to allow visitors to experience a space as though they themselves were, momentarily, for instance, Pilgrims or Shakers, stepping into the physical context of another, distinctly unmodern, cultural context. In point of fact, most period rooms were from elite houses, furnished with rare, aesthetically superior survivals.[15]

Henry Ford had a different idea. In the museum that bears his name (opened inauspiciously in October 1929 in Dearborn, Michigan), and Greenfield Village next door, he sought to put before the public material culture associated with ideal men who were both generic (the English yeoman) and specific (Thomas Edison). His was a reverence for the potential of the common man. He collected broadly in the familiar areas of household furnishings, but also in technology and architecture. He collected, among other categories of objects, bathtubs, and locomotives, and houses; his intent was to instruct the young not about bathtubs, bathing, or railroads, but about the virtues of ingenuity and perseverance. This was a material-culture-based education, an education that he believed would create model individuals and a model society. Ford believed in human progress and in American perfectibility. If the best in human virtue met the best in human ingenuity and opportunity,

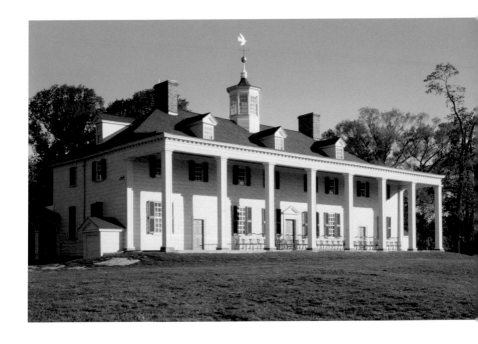

Fig. 7. Mount Vernon, designed by George Washington and others, Fairfax County, Virginia, 1752–93.

America could demonstrate hitherto unknown power and achievement and happiness to the world. His was, in other words, an object-based renovation of the Puritan notion of the city upon a hill.[16]

The collection of furnished rooms Henry du Pont assembled at Winterthur and the collection of buildings Henry Ford collected at Greenfield Village have their Texas counterpart in the National Ranching Heritage Center in Lubbock. Here vernacular buildings in stone, log, wattle, and dimensioned lumber made by Spanish, German, English, and other settlers in the nineteenth and early twentieth centuries have been gathered on one accessible site (fig. 9).[17] It is a collection of architecture, but it also incorporates furnished interiors, a Whitman's Sampler of those many other vernacular structures still surviving *in situ* out in the Texas hinterlands. The purpose of the project is to allow modern Texans (and others) to see and experience, through contact with material objects, the development of the livestock industry and to appreciate the hardships, ingenuity, and courage of the hardscrabble pioneering generations of Texans.

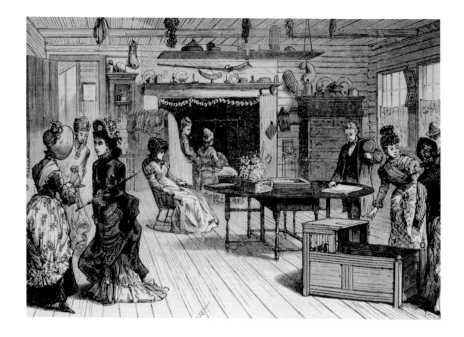

In all of these types of object-collections—the Great Man shrine, the period room, the assemblage of vernacular buildings—there is a usually unvoiced endorsement of anti-modernism, and a reverence for what is thought of as a Golden Age, usually understood to be a preindustrial, prelapsarian period when politicians were honest, men were full of courage, initiative, and ingenuity, and women were silent, virtuous helpmates.

By the time the first generation of proto-curators graduated from the Winterthur Program in Early American Culture in 1954, an MA degree program initiated by Henry du Pont and Charles and Florence Montgomery to train professionals to care for historic houses and large museum collections of period rooms and decorative arts materials made in America before 1840, the wind had already begun to change.[18] By the early 1970s the bellwether Mabel Brady Garvan and Related Collections of American Art at Yale University Art Gallery embodied

this change in a pathbreaking reinstallation spearheaded by Charles Montgomery, who had left Winterthur for a joint professorial-curatorial chair at Yale. The emphasis in this new scholarship and museum display turned decisively away from association between objects and great men or the assemblage of objects into accurate period rooms toward a formal interest in the aesthetic achievements of singular objects and singular artisans. This shift was in tune with the high modernist aesthetics of mid-twentieth-century painting and with New Criticism in literary studies; both took the object of study to be not the biographical associations or the archaeologically correct context of the thing, but rather the internal dynamics of its aesthetic achievement. The sculptural qualities of the individual objects and the mastery by individual artisans of their materials and object traditions resulted in an installation in which sofas floated mid-wall and the accoutrements of eighteenth-century cooking were assembled like a graphic design plate—as sculptural form and as two-dimensional pattern (fig. 10).[19] Scholars and the public were taught to see, recognize, and appreciate systems of symmetry, proportion, visual rhyme, and visual quotation. The gridiron, crane, teapot, skewers, toasters, and other iron utensils at Yale made no reference to great men or to the supposed virtues of cooking over an open fire, but rather, they were hung and judged as aesthetic abstractions, as black sculptural forms dramatized under bright lights against a starkly white, modernist background.[20]

Admiration and inquiry in much mid-twentieth-century scholarship was directed not at famous owners or at an authentic experience of period furnishings in accurately reinstalled period space, but at the artisan, the form-giver, the sculptor who found himself, perforce, cast not as an anti-modern exemplar but as a proto-modern hero. This focus on artisans as designers and artists, as well as craftsmen, led away from admiration for Washington's beds and toward an interest in the individual consciousness that conceived the object. The 2005 exhibition of John Townsend's cabinetry at the Metropolitan Museum—treating him to a retrospective as though he were Jackson Pollock—is a late instance of this mid-twentieth-century thinking.[21]

From about 1980, French theorists and historians, especially those associated with Fernand Braudel and *Les Annales*, crossed paths with New Historicism and scholars began to leaven their interest in formal aesthetic achievements with a keen interest in historic context and social complexity.[22] This context was understood to include the whole social and economic organism—not just the patrons, merchants, and military heroes, but porters and bankers, sailors and slavers, lumbermen and

smithies, and wives enduring eighteen pregnancies. This is where the concept of material culture—as a more democratic term with more democratic resonance—began to overtake and subsume the more discrete ideas of "fine arts," "decorative arts," "vernacular architecture," and the other tidy categorizations by which objects, scholarly publications, and museum departments had been identified. Current scholarship grows out of this late-twentieth-century revolution. It tends to focus on contrast, context, and incongruous abutment such as that between Juarez and El Paso; or between Frank Gehry's Guggenheim and gritty industrial Bilbao. These are sites where disparate cultures contact, or slide past one another without contact. It searches for enriched three-dimensional understanding of both objects and the many human players that make up both historical and present American experience.

Both the objects of attention and the shape of scholarly inquiry have shifted over the past quarter century. Scholars today are especially interested in hybridity, in points where cultures borrow from one another but remain distinct, aloof. Examples include the recently immigrated Laotian Hmong women hired by Mennonites to apply their formidable needlework skills in stitching the very different patterns of traditional Pennsylvania German quilts.[23] How do these two cultures regard this exchange? How do the customers who buy these artfully designed textiles understand this hybrid authenticity? Or to pick a past example, a drawing made in 1761 by Ezra Stiles, a clergyman who was very interested in the Native Americans of coastal Connecticut, records the furnishings of a very traditional wigwam (fig. 11). But this drawing records, among the traditional mats, iron pots, a dresser, and a tea table, prompting us to ask in what ways did English habits of tea drinking, textile-storing, and table-sitting appeal to Phebe and Elizabeth Moheegan?

The "object biography" is another way of investigating objects that has recently opened up a whole new set of questions and investigations.[24] Most scholarship privileges the moment of creation and asks what materials, ideologies, knowledge, trading patterns, technologies, surplus capital, and ingenuity had to come together to result in an artifact's creation. But the object biography takes a more expansive view, both in terms of the prehistory of the object and its subsequent history as it migrates from its fabrication date, through intervening generations, to the present. This narrative focuses on an artifact but it is above all a tale of cultural choice and change. An instance is provided by the case of Joshua Henshaw, whose portrait by John Singleton Copley and its frame clarify the potential for understanding such a longitudinal story, not as a simple provenance, clarifying ownership sequence and

*Fig. 9. El Capote Cabin (c. 1838), from Gonzales
County, National Ranching Heritage Center,
Texas Tech University, Lubbock, Texas.*

authenticity, but as a narrative in the vicissitudes in an object's value and legibility
(fig. 12). After a decade of public defiance of the Crown as Town Selectman,
Henshaw, who was the fifth wealthiest citizen of Boston, sat for Copley. But he
surmounted his portrait with the crest of his armigerous grandfather who as a
child was abducted and dispossessed, and as an adult was murdered while seeking
to recover his patrimony. Together, the frame and image record two kinds of
identity— that of Henshaw as an individual, a patriot with personal achievements
and recognizable features, and that of Henshaw as a member of a family line
disrupted during the Cromwellian wars. Beginning in 1827 the portrait gained
a third identity when it was first exhibited by the sitter's grand-niece as "a Copley,"
that is, when the reverence for the painter began to trump the personal memory
of the sitter.[25] How are these stories different from "Washington slept here" or
the formalist mantra "good-better-best"? Simply, they are richer and more encom-

Fig. 10. Wall display of eighteenth- and nineteenth-century iron objects, 1974, at Yale University Art Gallery.

passing; they incorporate more of the factors and more of the players that went into an object's making and survival; they tell us much more about the intervening cultures that used and preserved the object. And of course, they tell us more about ourselves.

The object biography approach complicates and enriches our understanding of townscapes as well as of individual objects; it critiques, for instance, the beautification approach of late nineteenth-century preservation projects such as Valley Forge in Pennsylvania (where the eponymic messy iron forge and associated eighteenth-century industrial buildings were removed to showcase the small vernacular house that was Washington's headquarters during the harsh winter of 1777–78). Equally, it critiques the "mono-moment" approach such as that so visible at Colonial Williamsburg, where nineteenth-century porches and structures were removed and eighteenth-century buildings were rebuilt to create a theatrical precinct "wholly"

Fig. 11. Ezra Stiles. "Phebe and Elizabeth
Moheegan's Wigwam." Niantic, Connecticut.
October 26, 1761. Ezra Stiles Papers, *Itineraries*,
p. 153, Beinecke Library, Yale University.

of the Revolutionary decade. A culturally rich biography of either site would not just incorporate the physical residue of the golden age of patriotic fervor and action, it would also respect, preserve, and interpret the spaces and structures built by previous and subsequent inhabitants, including those of the generation that sought so reverentially to preserve the site for the edification of the future. The basic assumption—that people think visually and learn from artifacts—remains in place, but the scope of that thinking and learning expands when it incorporates Time.

We all like objects—we see ourselves in our own objects, and we read others in the objects with which they furnish themselves. Clothing, cars, house facades, all of these speak eloquently to us of who we are and who we wish we were. Material culture as an approach looks at surviving objects as points of entry into

*Fig. 12. John Singleton Copley. **Joshua Henshaw**. c. 1770. Oil on canvas, 50 ¼ x 40 in. (127.6 x 101.6 cm). Fine Arts Museums of San Francisco, purchase, Mildred Anna William Collection, 1943.4.*

the thinking that brought them into existence, and into the very different thinking that has preserved them for us to see. It looks at design, patronage, trade patterns, technology, education, and family with an eye to understanding the texture of living and the mainsprings of action, not on the stage of public events, but in the ordinary zones of quotidian, private life. Few people write memoirs, keep diaries, exchange long letters in which they ruminate on time, space, community, aesthetic pleasure. But everyone acquires, uses, and discards (or saves, or gives) objects. Objects are, then, democratic as well as eloquent.

Objects are not just evidence about the past, they *are* the past. As William Faulkner put it, "the past is never dead. It's not even past."[26] The historian's subject is change, and the antiquarian's is stasis. The problem that material culture solves is that of using objects to describe and understand change and change that matters. Outliving humans (if they are made of durable materials and well cared for) objects carry their stories from year to year, telling each generation a bit of the truth about the past, and, I would argue, about the present.

Notes

1 The recent (somewhat bemused) turn to interest in "things" by scholars traditionally focused on language is exemplified by Barbara M. Benedict, "Encounters with the Object: Advertisements, Time, and Literary Discourse in the Early Eighteenth-Century Thing-Poem," *Eighteenth-Century Studies*, vol. 40, no. 2 (Winter 2007): 193–207. The author wishes to thank Paul Groth, Richard Hutson, Kathleen Moran, and Christine Rosen for their helpful comments on an early draft of this essay; and Sylvia Houghteliing for her research assistance.

2 The ideas developed here germinated as a course I developed as an aspect of my PhD qualifying exams in American Studies at Yale University in 1977 under the direction of Alan Shestack; I had the opportunity to co-teach that course "Art and Artifacts" as a member of the faculty in history of art at that institution from 1978 to 1981 with Charles F. Montgomery, and after his untimely death, with Jules D. Prown. More recently I have taught updated versions of the course with Dell Upton and Patricia Berger at the University of California, Berkeley. For a statement of some of the concepts we were working on in the earlier years, see Jules David Prown, "Mind in Matter: An Introduction to Material Culture Theory and Method," *Winterthur Portfolio* 17 (Spring 1982): 1–19.

3 See Margaretta M. Lovell, "The Picture in the Painting," in *Art in a Season of Revolution: Painters, Artisans, and Patrons in Early America* (Philadelphia: University of Pennsylvania Press, 2005), 26–48.

4 Laurel Thatcher Ulrich, *The Age of Homespun: Objects and Stories in the Creation of an American Myth* (New York: Alfred Knopf, 2001), Chapter 1, 12–40; Christopher Monkhouse, "The Spinning Wheel as Artifact, Symbol and Source of Design," in Kenneth L. Ames, ed., *Victorian Furniture: Essays from a Victorian Society Symposium* (Philadelphia: Victorian Society in America, 1982), 154–72; Beverly Gordon, "Spinning Wheels, Samplers and the Modern Priscilla: The Images and Paradoxes of Colonial Revival Needlework," *Winterthur Portfolio* 33, no. 2/3 (Summer/Autumn 1998): 163–94.

5 See Jules David Prown, "The Promise and Perils of Context," *American Art* 11, no. 2 (Summer 1997), 20–27; Jules David Prown, "In Pursuit of Culture: The Formal Language of Objects," *American Art* 9, no. 2 (Summer 1995): 2–3; Jules David Prown, "Art History vs. the History of Art," *Art Journal* 44 (Winter 1984): 313–14. For the perspective of an archaeologist, see Chris Gosden, "Making Sense: Archaeology and Aesthetics," *World Archaeology* 2 (Oct. 2001): 163–67.

6 For studies of material culture and consumerism, see Cary Carson, Ronald Hoffman, and Peter J. Albert, eds., *Of Consuming Interest: The Style of Life in the Eighteenth Century*, (Charlottesville: University Press of Virginia, published for the U.S. Capitol Historical Society, 1994); see also Ann Smart Martin, "Makers, Buyers, and Users: Consumerism as a Material Culture Framework," *Winterthur Portfolio* 28, no. 2/3 (Summer/Autumn 1993): 141–57.

7 See Lovell, "The Picture in the Painting," in *Art in a Season of Revolution*, 26–48.

8 See Margaretta M. Lovell, "Money, Art, Family and the Cabinetmakers of Newport," in Lovell, *Art in a Season of Revolution*, 225–66.

9 Jennifer L. Anderson, "Nature's Currency: The Atlantic Mahogany Trade and the Commodification of Nature in the Eighteenth Century," *Early American Studies: An Interdisciplinary Journal* 2, no. 1 (2004): 47–80. For an earlier overview, see Cathryn J. McElroy, "Furniture in Philadelphia: The First Fifty Years," *Winterthur Portfolio* 13 (1979): 61–80.

10 See, for instance, Lovell, "Money, Art, Family" in *Art in a Season of Revolution*; and Charles F. Montgomery, *A History of American Pewter* (New York: Dutton, 1978).

11 See, for instance, Charles B. Hosmer, Jr., *Preservation Comes of Age: From Williamsburg to the National Trust, 1926–1949* (Charlottesville: University Press of Virginia, published for the Preservation Press, National Trust for Historic Preservation, 1981); and Robert E. Stripe and Antoinette J. Lee, eds., *The American Mosaic: Preserving a Nation's Heritage* (Washington, D.C.: U. S. Committee/International Council on Monuments and Sites, 1987).

12 Barbara J. Howe, "Women in Historic Preservation: The Legacy of Ann Pamela Cunningham," *Public Historian* 12, no. 1 (Winter 1990): 31–61.

13 Instrumental in the preservation of the house, grounds, and furnishings of Olana was David C. Huntington, author of *Landscapes of Frederic Edwin Church: Vision of an American Era* (New York: Braziller, 1966).

14 Rodris Roth, "The New England, or 'Old Tyme,' Kitchen Exhibit at Nineteenth-Century Fairs," and Melinda Young Frye, "The Beginnings of the Period Room in American Museums: Charles P. Wilcomb's Colonial Kitchens," in Alan Axelrod, ed., *The Colonial Revival in America* (New York: W. W. Norton, 1985), 159–83, 217–40.

15 Diane H. Pilgrim, "Inherited from the Past: The American Period Room," *American Art Journal* 10, no. 1 (May 1978): 4–23; and Hillary Murtha, "The Reuben Bliss Bedchamber at the Brooklyn Museum of Art: A Case Study in the History of Museum Period Room Installations," *Winterthur Portfolio* 40, no. 4 (Winter 2005): 205–18.

16 James S. Wamsley, *American Ingenuity: Henry Ford Museum and Greenfield Village* (New York: Harry N. Abrams, 1985); Walter Karp, "Greenfield Village," *American Heritage* 32 (December 1908): 99–107; Michael Wallace, "Visiting the Past: History Museums in the United States," in Susan Porter Benson, Stephen Brier and Roy Rosenzweig, eds., *Presenting the Past: Essays on History and the Public*, (Philadelphia: Temple University Press, 1986), 137–64.

17 On the founder of the National Ranching Heritage Center, see Jane H. Kelley and Fred Wendorf, "Obituary: William Curry Holden, 1896–1993," *American Antiquity* 59, no. 4 (Oct. 1994): 672–75.

18 Charles F. Montgomery, "The First Ten Years of Winterthur as a Museum," *Winterthur Portfolio* 1 (1964): 52-79.

19 Charles F. Montgomery, "1776: How America Really Looked," *American Art Journal* 7, no. 1 (May 1975): 52-67.

20 "New Installation of Yale's Garvan Collection," *Antiques* 103 (June 1973): 1050; J. E. Cantor, "A Chair is More than Something to Sit On," *ArtNews* 73 (April 1974): 64-66; "Object Lesson: New Installation of American Artifacts," *Industrial Design* 21 (Jan. 1974): 55–59; and "Working Gallery Made for Students," *Architectural Record* 156 (Oct. 1974): 98–99.

21 See Morrison H. Heckscher, *John Townsend: Newport Cabinetmaker* exh. cat. (New York: Metropolitan Museum of Art; New Haven, Yale University Press, 2005); see also Jay Robert Stiefel, "John Townsend, Newport Cabinetmaker," *Journal of the Early Republic* 26, no. 4 (Winter 2006): 670–76.

22 Fernand Braudel, *Civilization and Capitalism, Fifteenth Century to Eighteenth Century*, trans. Sian Reynolds (New York: Harper & Row, 1981); and Stephen Greenblatt and Catherine Gallagher, *Practicing New Historicism* (Chicago: University of Chicago Press, 2000).

23 Jean Henry, "Hmong and Pennsylvania German Textiles: Needlework Traditions in Lancaster County," *Folk Art* 20, no. 2 (1995): 40–46.

24 See Arjun Appadurai, *The Social Life of Things* (1986), especially Igor Kopytoff, "The Cultural Biography of Things: Commoditization as Process," in Arjun Appadurai, ed., *The Social Life of Things* (Cambridge: Cambridge University Press,1986), 64–94; also Christopher Y. Tilley, *Handbook of Material Culture* (London: Sage Publications, Inc., 2006), 75–81.

25 Margaretta M. Lovell, "The Remembering Eye: Copley's Men and the Case of Joshua Henshaw," in Lovell, *Art in a Season of Revolution*, 94–140.

26 William Faulkner, *Requiem for a Nun* (New York: Random House, 1951), I, iii.

A Journey of a Thousand Miles Begins with a Lot of Luggage: Spanish Colonial Material Culture in the U.S. Southwest

Kelly Donahue-Wallace

When Captain Joseph de Urrutia of San Antonio de Béxar died in 1741, local authorities made an inventory of his possessions.[1] They listed items one would expect a career army officer to own: a dagger, a shotgun, a broadsword, a bugle, an embroidered saddle, two ornamented blunderbusses, and a leather shield. His clothing likewise reflected the elevated social status he enjoyed as the commander of the Béxar presidio:[2] a red velvet suit, another suit of pearl-colored cut velvet, a scarlet cloak, a scarlet scarf, a scarlet waistcoat of French linen, a beaver hat, a pair of glasses in a tortoiseshell case, and three handkerchiefs of Mexican cotton, among other items. Some of the furnishings in his home were common: a bed, an embroidered bedspread, a small box for papers, an earthenware jug, a silver rosary, two cushions, two *metates* for grinding corn, a *comal* for cooking tortillas, a pestle and mortar, copper kettles and candlesticks, and a table. Other items, however, reveal that Urrutia enjoyed the finer things in life. He owned sheets of the finest French linen, pillows likewise of French linen with cases made of scarlet taffeta, a silver salt cellar, a polychrome lacquer chest with tray and cast lock, silver spoons, English table knives, twenty varas of lace from Flanders, additional yardage of two types of French linen, eighteen dozen Dutch knives, three pounds of Chinese silk in red and black, nearly eight varas of brown Chinese taffeta, a Chinese porcelain

Detail, fig. 5

basin, six necklaces of imitation pearls, glass beads in different colors, a walking cane in a silver sheath, two paintings on copper in gilded frames, a large canvas painting of Our Lady of Sorrows, and a painted screen bearing an image of cavorting ladies and gentlemen.[3] Beyond revealing that Captain Urrutia had a fondness for red clothing, the inventory says a great deal about the material culture of the US Southwest in the eighteenth century. Most significantly, it reveals that residents of colonial Béxar had access to a truly global array of goods.

But wait! Urrutia's probate inventory seems not to agree with the Spanish Borderlands of the popular imagination. The Hispanic cities and villages of the U.S. Southwest, whether San Antonio, Santa Fe, or Los Angeles, have suffered virtually identical treatment in many Hollywood films. A dirt street populated by stray dogs, children, and women in *rebozos* is flanked by small, single-story adobe structures. Home interiors, when shown, consist of one or two rooms that are sparsely outfitted with a chair and table of rough-hewn wood. These images offer little that could be described as elegant or lavish, certainly no French linen, Chinese silk or lace, or elegant painted screens. In fact, Urrutia's inventory includes most of the items you would expect to find in a well-to-do home in central New Spain. Hollywood movies, however, are based on photographs and chronicles by early Anglo observers who had little understanding of Hispanic material culture. The photographers and authors furthermore saw the region after decades neglect by a viceregal and later republican government busy with the independence movement and the building of a new nation. These nineteenth-century sources, however, fixed an image of the Spanish Borderlands as unremittingly poor. With Urrutia's inventory as a starting point, we will restore some of the glory of colonial Béxar, considering the breadth of goods that filled trunks, boxes, and baskets traveling up the Camino Real from central and northern New Spain to satisfy the needs of the Captain and his peers. What might the San Antonio's Governor's Palace or another elite home in the Spanish Borderlands have looked like? To reimagine that place and time, we will need to travel around the globe.

Most settlers in colonial New Mexico and Texas lived in rustic homes with sparse furnishings, much like agricultural and frontier people did throughout the globe. In Texas many of these were *jacales*, wattle-and-daub constructions that were not as sturdy as the better adobe and stone buildings also employed in the colonial Southwest. But not everyone eked out their existences, and San Antonio de Béxar saw poor settlers acquire land and livestock, and engage in trade and small industry to create a comfortable life. Additional well-to-do settlers also came to the region to assume government or military posts, such as Captain Urrutia, or simply to pursue

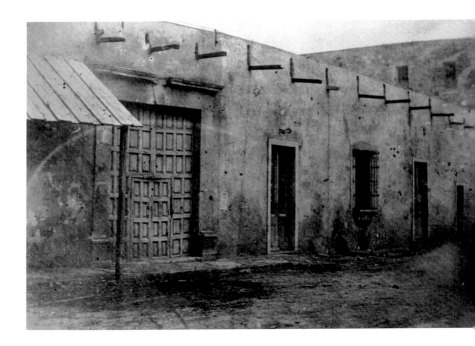

*Fig. 1. **Beramendi Palace**, begun in 1770s, San Antonio, Texas. Photograph, c. 1870, the Institute of Texas Culture, San Antonio, Texas.*

greater wealth, such as the Spaniard Fernando de Beramendi (or Veramendi), who settled in San Antonio in the 1770s; his home is seen in a nineteenth-century photograph (fig. 1). These residents purchased local goods from the increasing numbers of artisans that settled in the area. They likewise took advantage of the trading relationships between central New Spain and the rest of the world to acquire a range of goods. Add items illicitly traded with French and American territories (such as possibly Urrutia's beaver hat and the eighteen dozen Dutch knives he likely intended to resell), and *bejareños* (inhabitants of San Antonio de Béxar) could acquire virtually anything. Like the homes in viceregal Santa Fe that colonial art historian Donna Pierce has researched, Urrutia's household was truly a hybrid.[4] To understand his goods requires exploring the global aspect of Spanish colonial culture.

New Spain was a hub of international trade by the early eighteenth century, when Spanish authorities settled Coahuiltecos and Canary Islanders along the San Antonio River. Strict laws restricted trade in the Spanish colonies, and *bejareños* were legally limited to goods shipped up the Camino Real de los Tejas. Created

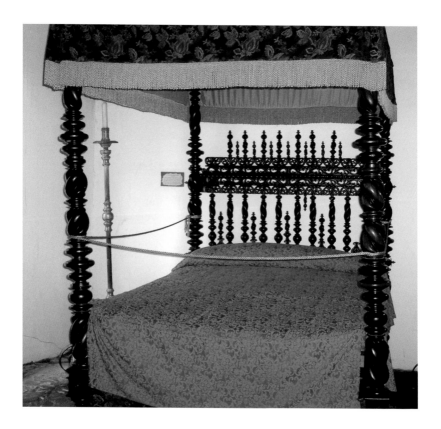

Fig. 2. Unknown maker, New Spain.
Canopy Bed. *Eighteenth century. Wood.*
Governor's Palace, San Antonio, Texas.

to maintain centralized control over local economies, to protect royal monopolies of everything from playing cards to tobacco, and to limit contact between Spanish colonists and the French and American inhabitants of North America, the trade restrictions were undermined by a vibrant exchange of contraband. Hence, via legal and illegal means, *bejareños* had access to a rich array of materials.

Let us start close to home, with items Urrutia may have acquired locally. The settlers of San Antonio de Béxar traded extensively with native peoples[5] in the region. Although Urrutia's inventory reveals nothing that indisputably came from this economic exchange, colonists commonly acquired animal hides and other items from area Indians. In 1779, Juan José Flores de Abrego owned satchels made from buffalo skins likely purchased from native peoples. Inventories and archeo-

logical excavations from colonial New Mexico have similarly revealed that settlers and Pueblo Indians regularly exchanged pottery and other items.[6] And while Urrutia's inventory may not have identified the provenance of the pottery jars he owned, archeological excavations have revealed settlers in San Antonio owned baskets and pottery made by local Amerindians.[7] Interestingly, both in New Mexico and in Texas, native goods tended not to be listed in colonists' wills and inventories, suggesting that these items were so mundane as to be not worthy of registering.

By the mid-eighteenth century, San Antonio de Béxar also had a number of skilled craftsmen and artisans, permitting colonists to convert raw goods into manufactured items. There were tailors, carpenters, and blacksmiths, suggesting that perhaps Urrutia's leather shield, kitchen items, suits, and perhaps even some of his weapons were made in San Antonio from local or imported materials.[8] The captain's bed might have been made by a *bejareño* carpenter, although I suspect Urrutia would have preferred one of the ornate canopy beds fashionable in Spain and the Americas in the late seventeenth and eighteenth centuries (fig. 2). Other beds described in local inventories are described as *camas de tablas*, or plank beds, which were likely made by area carpenters.

Despite his wealth, merchant Fernando de Beramendi appears to have displayed some local furniture in his home. The 1783 inventory of his goods included a bench and a table with one drawer, both made of either juniper or cypress, trees that grew in abundance in Texas. Beramendi also owned nine rush-bottom chairs described in his inventory as "*en bruto*," meaning unfinished, perhaps a sign that the chairs were the product of frontier craftsmen. Carpenters and furniture makers active in cities with guilds, such as Mexico City, were required to demonstrate their skill in the day's fashionable and refined furnishings, suggesting either that the maker of Beramendi's rustic furniture was not guild trained or that the chairs were not completed.

Settlers may likewise have taken advantage of the skilled masons who traveled to the region to construct the Franciscan missions there.[9] There is no reason to think that the master craftsmen who carved the ornate doors at the missions, such as Antonio Salazar or even the swashbuckling Pedro Huizar, the lothario perhaps responsible for the "rose window" at San José y San Miguel de Aguayo, did not do the same for local settlers.[10] The home of Pedro de Beramendi, constructed in the mid-eighteenth century and torn down one hundred years ago, undoubtedly required professional labor. It was described in 1783 as a stone house, eighty-one varas long; contemporary churches were only thirty to thirty-five varas on their longest axis, making the Beramendi house truly immense. The home boasted a

tiled entry and formal sitting room. Since there is no evidence of a San Antonio tile-making industry, it seems likely that Beramendi's examples came from Puebla, home of the ceramics known as *talavera poblana*, or even from Spain; there are many examples of colonial Latin American structures with tiles brought at great expense from Spain. Beramendi's house also had at least three, "two-handed" paneled doors.[11] A nineteenth-century photograph reveals that at least one set of these double doors was set within a larger opening made to accommodate carriages entering the *zaguán* or passageway into the home's interior courtyard. The photograph also reveals the stone lintel and pilasters surrounding the opening, work likely done by a skilled mason. Beramendi's home likely has ornamental painting throughout its walls. The traces of mural painting seen today at the Governor's Palace may provide a glimpse of the ornate pictorial and decorative programs settlers had executed on their walls, a practice common throughout the Hispanic world.

But even as late as the 1780s, Texas lacked sufficient specialized laborers, and most manufactured goods, like Beramendi's tiles, were transported up the Camino Real for resale at the presidio and the shops of civilian merchants. Many of the items were indigenous to New Spain, and were either native practices continued after the Spaniards' arrival or crafts introduced from Spain. Urrutia's chest with tray and cast lock, for example, is described in the inventory as an example of Peribán woodworking (fig. 3). Peribán, in the state of Michoacán, was home to indigenous artists who had created painted lacquerware since the Precolumbian era. In the colonial period, tables, boxes, desks, chests, bowls, and other items from Peribán were collected by the breadth of colonial society and were exported to Europe. The items were created by painting in dark lacquer, and burnishing each of several layers. The designs were incised into the lacquer and filled with red, blue, green, yellow, orange, black, and white pigments.[12] Although the inventory calls it simply a box (*caja*), Urrutia's chest was likely an *arquilla* or larger *escritorio*, used to house documents and provide a writing surface. And despite the inventory's silence on its decoration, like most Peribán work, Urrutia's likely depicted heraldry, mythological characters, fantastic creatures, or courtly figures surrounded by vegetal decoration and intricate strapwork.

Other chests listed in San Antonio inventories were likely also products of central New Spain. Urrutia's probate list includes a small writing box made of pine. These items, also known as *papeleras*, were common in colonial homes (fig. 4). Many of the extent examples were made in Oaxaca by craftsmen inspired by similar boxes made in sixteenth-century Nuremberg.[13] Based on the model of the larger *vargueño*, the *papelera* had several drawers for writing implements and

for storing correspondence, but lacked the *vargueño's* dropped writing surface. These objects could be quite simple or dramatically ornate, with inlaid decoration, relief carving, gilding, or other embellishments. Based on the material listed, Urrutia's *papelera* likely came from Michoacán; pine was a popular material for craftsmen in this region, whose work was widely collected. The inventory did not identify the location of Urrutia's writing box but the *papelera* appears alongside his bedroom furnishings, suggesting that it stored his most intimate papers.

The glasses case Urrutia owned was but a small example of the tortoiseshell boxes Mexican craftsmen produced in the colonial era. Tortoiseshell boxes used silver hinges and clasps; they frequently also bore silver ornamental appliqué and sgraffitto designs. Mexican colonists could purchase tortoiseshell objects from artisans working in Puebla, but the items were also imported from Spain and Asia. Other popular uses of tortoiseshell in the colonial era included the disks known as *chiqueadores* that women wore as beauty marks or to cover blemishes, and as frames surrounding the circular *escudos de monjas* or nuns' shield.

Juan José Flores de Abrego's inventory included one trunk and three chests. One of the latter was likely an example of lacquerware as it is listed in the inventory as coming from Michoacán; this designation came to be (and still is) synonymous with polychromed lacquerware (fig. 5). Flores de Abrego's example was likely a particularly fine work, as it is described in his inventory as "new with a lock and key, one and ⅛ varas long."[14] The other chests may have been examples of *taracea*, a popular wood encrustation technique adopted from the Moorish art of Southern Spain. These fine pieces were collected in great numbers by patrons in New Spain and were mainstays in the elite viceregal home. Colonial artists inlaid boxes with ivory, mother-of-pearl, bone, and different colors of wood. The incised designs were highlighted with a paste to make the secular and religious images easier to read. The incised narratives on these pieces in fact provided Mexican artists' with their most regular opportunities to explore genre subjects, as secular art took a back seat to religious themes in other forms of painting and sculpture.

Fig. 5. Unknown maker, New Spain. **Michoacán Tray.** *Seventeenth century. Paint and lacquer on wood. Length: 42 ⅛ in. (107 cm). Museo de América, Madrid.*

The trunk in Flores de Abrego's inventory was a leather item known as a *petaca*, a word derived from the Aztec *petacalli*, referring to bundled fibers. During the colonial era, craftsmen made *petacas* of leather and wood, and covered them with designs of leather appliqué and agave-thread embroidery (fig. 6). As with the *taracea*, the *petaca's* designs were commonly of secular themes and sometimes quite racy.[15]

The jewelry and silver utensils Urrutia owned were also likely items made in central New Spain. Long before the arrival of the Spaniards, indigenous artists worked gold, silver, and precious stones into fantastic and beautiful objects. And while the silversmithing profession was soon dominated by Spaniards to the exclusion of indigenous artists soon after the conquest, Mexico nevertheless persisted in producing elegant examples of jewelry and silver that combined European, indigenous, and new colonial forms and tastes. While Urrutia's six pearl necklaces and silver cross were fakes, the silver rosary likely cost a good deal. Mexican rosaries were coveted items in New Spain and Europe. Ships leaving Veracruz for European

ports regularly carried these religious items; one ship in 1784 carried thirty gross (that is, 4,320) of rosaries from Veracruz to Cádiz.[16] The appearance of Urrutia's rosary may be gleaned from portraits painted in colonial New Spain, which reveal a host of materials, from silver and gold to precious stones (fig. 7).

Urrutia was not alone in his admiration for New Spanish jewelry; *bejareños* apparently purchased these luxury items in substantial quantities. The goods confiscated from Governor Angel de Martos in 1767 contained ten dozen rosaries. A 1768 inventory of items purchased by two San Antonio merchants included twelve dozen necklaces and an equal number of rosaries.[17] Juan José Flores de Abrego's wife owned several gold and pearl earrings,[18] perhaps purchased from Beramendi's shop, which had thirty-three pearl necklaces and two pairs of gold earrings for sale when the owner died in 1783.[19] Hence, *bejareños'* wealth was at least partially worn on the body in the form of large filigree chandelier earrings, pearl chokers, diamond pins, and other examples of New Spanish jewelry.

*Fig. 6. Unknown maker, New Spain. **Petaca**.*
Eighteenth century. Leather and agave thread,
approx. 19 ⅝ x 29 ½ x 17 ¾ in. (50 x 75 x 45 cm).
Dallas Museum of Art.

Fig. 7. Miguel Cabrera, New Spain. **María de la Luz Padilla y Cervantes.** 1760. Oil on canvas, 43 x 32 in. (109.2 x 83.8 cm). Brooklyn Museum.

Fig. 8. Miguel Cabrera, New Spain. **From Spaniard and Mestiza: Castiza.** 1763. Oil on canvas, 52 x 39 3/4 in. (132 x 101 cm). Museo de América, Madrid.

Other examples of indigenous products Urrutia owned included his two metates, the stones used to grind corn; his *comal* for cooking tortillas, and his cotton handkerchiefs from Sultepeque. Like the indigenous lacquerware, woven cotton attracted purchasers from all ethnic groups and social strata, as evidence by the *casta* paintings. These images of New Spain's racial diversity, especially those produced in the mid-eighteenth century by Miguel Cabrera, are valuable sources of information on the viceroyalty's material culture (fig. 8). Colonists from all groups wear Mexican woven and embroidered cotton in the paintings, and most San Antonio inventories include these common textiles. The New Spanish fabrics were available in great supply. Beramendi's shop offered blanket cloth from Puebla, sixty-five varas of rebezillo, a Puebla cotton shawl, twenty-seven and one-quarter varas of striped serge, and blue and red coarse wool that was likely also from New Spain.

Another local product that is illustrated in the *casta* paintings is shoes, and these too appear in abundance in San Antonio inventories. Although the shoes in colonial Texas and New Mexico are described as Córdoban shoes, this label refers to their goat-leather material rather than their provenance. Hence the shoes may

very well have been stitched in New Spain. An inventory of items found in Marcos Vidal's San Antonio shop reveals that *bejareños* could purchase shoes locally from merchants who also sold cloth, stockings, wine, soap, hard liquor known as *aguardiente*, and chocolate, among other things.[20]

Urrutia's inventory reveals that the Mexican trade with Europe, which was unabated in the eighteenth century, reached Béxar. Some of the best descriptions of the material culture Mexicans imported from Europe in this era come from the *Gazeta de México*, a biweekly newspaper published in the viceregal capital. Each issue included shipping registers recording the goods that entered and left the ports of Veracruz and Acapulco. Beds, chairs, tables, benches, clothing, and pottery came on the ships. In 1784, for example, a ship from Cádiz brought twelve stools, six chairs, and a dresser.[21]

Urrutia clearly took advantage of the arrival of European goods, as demonstrated by the *botija* or olive jar listed in his inventory as a product of Castilla, Spain.[22] The most common European objects in his inventory, however, were textiles, and Urrutia owned two types of French fabrics. Most inventories of *bejareños'* belongings similarly include yardage of European textiles, proving that as with their jewelry, colonists wore their wealth, purchasing the finest cloth they could afford. An observer in eighteenth-century Lima, for example, described colonists taking their taste for lace "to a prodigious excess."[20] Colonial authorities throughout the Americas in fact tried to regulate which populations could wear fine clothing, but sumptuary laws limiting silks to Spaniards were wholly unsuccessful.

Imported textiles also caused problems when purchased on the black market. When San Antonio resident Marcos Vidal was arrested for smuggling goods from Louisiana, for example, he had chintz from Holland, linen from Germany, shag from England, cloth from Spain, and ribbon from Italy.[24] The 1783 inventory of goods belonging to Fernando Beramendi provides the greatest quantity and diversity of imported European fabrics.[25] Beramendi's stock included cloth from Brittany, Rouen, Barcelona, Granada, and Flanders, in addition to examples from China and central New Spain.[26] Hence, rather than imagine the residents of borderlands towns as wearing drab and dark sack cloth, we should picture the streets bustling with characters outfitted in a rainbow of colors. But let us return to their home furnishings.

Although paintings, prints, and sculptures likewise crossed the Atlantic throughout the colonial era, it is likely that the paintings Urrutia owned came from central New Spain. Mexico City, Puebla, Querétaro and other colonial cities had

robust painting schools in the eighteenth century. Painters in these cities practiced regional variations of New Spain's late Baroque style, with idealized figures, pastel colors, and profusely ornamented compositions. Most founded in the late sixteenth century, painters' guilds controlled production, regulated membership, and ensured the technical proficiency of their members. They executed works in oil on canvas as well as on copper plate. Painting on copper plate, a support also employed by contemporary European artists, was practiced in New Spain with increasing frequency in the seventeenth and eighteenth centuries. Like their peers in Flanders and Germany, Mexican artists admired the medium's durability and rich colors. Urrutia's pair of unattributed copper paintings may have been the work of Nicolas Enríquez, a Mexican painter active between 1730 and 1768, who appears to have specialized in copper plate images (fig. 9). Whoever the artist, the paintings may have been landscapes, which were immensely popular among New Spain's art collectors. His oil on canvas painting of the Virgin of Sorrows may have offered a complicated treatment of the topic or have been a simpler devotional painting depicting the suffering Virgin against a dark background. The subject likely reflected his personal devotional preference. Other settlers in the Spanish Borderlands similarly brought Mexican or Spanish paintings of favorite devotions to the region. Many *bejareños*, such as Vicente Albares Travieso, owned paintings of Our Lady of the Candelaria (or Candlemas), a Marian cult popular among Canary Islanders.[27]

Although Urrutia only had paintings, other colonists in San Antonio owned sculpted images as well. In 1815, María Concepción de Estrada owned six sculpted images of saints and two crucifixes.[28] Juan José de Abrego owned five paintings on canvas of unknown subjects when he died in 1779; he also had a sculpture of the Christ Child described in his inventory as being one vara tall (fig. 10).[29] Again, the provenance of these full round images is impossible to determine today, but Mexico City, Guatemala, and Quito had thriving sculpture guilds in the eighteenth century. Records in the *Gazeta de México* reveal that these American sculpture schools shipped their wares throughout the viceroyalties and to Europe. The images could likewise have been imported from Europe, as shipments continued to cross the Atlantic to outfit colonial homes and churches. In all cases, colonial and Spanish sculptors preferred polychrome figures sculpted in wood and frequently dressed or otherwise made to look more lifelike—the process was called *encarnación* or incarnated—with the addition of ivory teeth, wigs, glass eyes, crystal tears, and articulated joints. Abrego's Christ Child sculpture was likely an *imagen de vestir*, or dressed sculpture, like most

*Fig. 10. Quito School. **Christ as Savior.** Paint on wood. Eighteenth century. 31 in. (78.7 cm). New Orleans Museum of Art, gift of Dr. and Mrs. Edward S. Fleming (74.245).*

*Fig. 11. Unknown maker. **Biombo with Emblems by Otto van Veen.** Eighteenth century. Oil on wood, 59 ½ x 153 in. (151.2 x 388.6 cm). Dallas Museum of Art.*

similar images of the same dimensions. *Imágenes de vestir* became popular in Spain and the Americas in the sixteenth century and thrived in the Spanish borderlands until mass-produced plaster sculpture became more popular.

Of course, the biggest demand for paintings and sculpture created outside the region came from mission and parish churches. The churches appear largely denuded of their art today, but Jacinto Quirarte has reconstructed the ornamental programs of the San Antonio missions based on inventories and descriptions. The mission of San Francisco de la Espada had perhaps the largest collection of painting and sculpture, with fifteen sculpted saints and eleven paintings.[30] If Clara Bargellini's research concerning the provenance of colonial New Mexican mission art holds true for Texas as well, some of the objects at La Espada and other missions in Texas were new commissions from artists in Mexico City while other items were hand-me-downs from churches in northern New Spain.[31] Today only a handful of the paintings and sculptures remain in situ at any of the missions.

Captain Urrutia's inventory also helps us to appreciate how the influence of trade with Asia affected colonial art even on the periphery of the viceroyalty. Spanish ships known as the *Manila Galleons* began carrying Asian merchandise from Manila to the port of Acapulco in 1573 and continued until the early nineteenth century. Upon reaching New Spanish shores, the goods from China, India, Ceylon, and Japan were carried by mule to Mexico City and Veracruz, where they embarked

for Spain. Many of the items remained in New Spain, and Mexican merchants sold porcelains and cloths to local colonists. In 1777, a visitor to Mexico City's central market marveled at the breadth of Asian goods colonists could purchase: "What a diversity of porcelains and ceramics from China and Japan!… What curiosities of ivory, silver, and metal…! What sets of crystal from China!"

Like his peers throughout New Spain, Urrutia clearly treasured Chinese textiles and possessed different colors and qualities of silk. As with French linens, yardage of Chinese silk appears in virtually every inventory compiled in eighteenth-century San Antonio. When it came to clothing in viceregal New Spain, red was definitely the new black in the seventeenth and eighteenth centuries, as colonists traded in Spain's dark clothes for Asian-inspired colors. Urrutia's preference for red clothing is furthermore evidence of San Antonio's early participation in the aesthetic movement known as chinoiserie. This delight in Asian-looking things also affected the patterns found in New Spanish textiles and the designs painted on lacquerware furniture. It should be noted, however, that the dye that made the clothing red was derived from the cochineal bug that inhabited the tequila-producing maguey plant in central and southern Mexico. The cut of the clothing on the other hand was undoubtedly French, as Mexicans developed a taste for French fashions with the coronation of Philippe of Anjou, better known as Philip V, as king of Spain in 1700.

The *Manila Galleon* goods sparked a taste not just for Chinese silks, but also for other Asian and Asian-inspired items. Porcelain was particularly coveted. Urrutia's inventory included a Chinese porcelain basin. Valued at sixteen pesos, the basin was one of the most expensive single items in his inventory, suggesting that it was quite large. Other *bejareños* owned these exotic specimens. Juan José Flores Abrego, for example, owned "four small pots from China."[33] The majolica pottery known as *talavera poblana* was immediately affected by Chinese porcelains, and soon Mexican wares displayed similar decorative motifs and blue on white coloring. Hence Beramendi's tiled entryway, which was probably made in New Spain, may have likewise revealed Asian influence.

The most obviously Asian-inspired item in any San Antonio inventory, however, was Urrutia's painted screen featuring gallivanting ladies and gentlemen. Japanese painted screens called *byo-bu* (*byo-* meaning protection and *bu* meaning wind) may have appeared among the earliest shipments carried by the *Manila Galleon*. The first documented *byo-bu* (or *biombo* in Spanish) arrived in 1610 with goods sent to New Spain by the Japanese shogun Takugawa Ieyasu; he sent up to

ten more in 1614.[34] By the seventeenth century, these gifts fueled a fashion for *biombos* in the homes of the viceregal elite. Soon artists in Mexico City and Puebla used their own ingenuity to build and paint colonial versions.[35]

Biombos are classified by where they were used in their owners' homes, although the movable objects could be placed anywhere homeowners desired privacy or ornament. *Biombos de cama*, as the name suggests, were made for the bedroom. These screens, for obvious reasons, were tall, measuring up to three meters high to shield the bed from curious eyes. The other type of *biombos* were created for the *estrado* or parlor, where homeowners entertained their guests seated on a low platform. The *biombos rodastrados* framed the sitting area and have been likened to a theatrical backdrop for the elegant reunions.[36] Urrutia's *biombo* may have been a *biombo rodastrado*. His inventory includes several cushions and pillows, which may have served as seating in his estrado or parlor. In the seventeenth and early to mid-eighteenth centuries, colonial New Spanish homes typically included more cushions, stools, benches, and carpets than chairs, since women's large skirts made sitting on the floor easier than squeezing into the era's armchairs.[37]

In the eighteenth century, however, the influence of French and English furniture meant that households increasingly used armchairs and low benches for seating. Mexican furniture makers were particularly impressed by the elegant lines found in works made in the Queen Anne style as well as those by Thomas Chippendale. New Spanish craftsmen adapted their cabriole legs, claw-and-ball feet, and ornate splats. They combined these with locally popular chinoiserie gilded and lacquered ornamentation and decorative elements such as c-scrolls, s-scrolls, shells, and vegetal patterns. The San Antonio inventories unfortunately do not supply sufficient detail to determine whether Urrutia and others owned these stylish pieces, but the bench in Flores de Abrego's inventory likely occupied the main salon of his home and perhaps rested in front of a *biombo*, which was a common practice in the later eighteenth century.

Whether seen while sitting on pillows or on chairs, colonial *biombos* adapted Japanese materials and images to the Latin American context. Latin American *biombos* comprised from four to as many as twenty of these panels joined with metal hinges. The screens were painted on one or both sides in a broad variety of themes including Greco-Roman mythology, history, allegory, genre, festival scenes, urban views, emblems (fig. 11), and moral lessons. Urrutia's *biombo* with its image

of gallivanting ladies and gentlemen may have looked like an example now found in a private collection in Mexico City. This scene of recreation has been likened to the contemporary French fashion for paintings of the *fête gallante*.

Urrutia's *biombo* seems to me to be the strongest evidence for the need to reevaluate the material culture of Spanish colonial Texas. Although not every colonist owned such an extensive array of luxury items, some did. Urrutia's belongings demonstrate that at least San Antonio, like Santa Fe, El Paso, and other larger communities in the U.S. Southwest, participated in the cultural crossroads that was the viceroyalty of New Spain. Imagining his home now, we can see items from New Spain, Asia, and Europe. There are fine materials, embellished objects, fashionable clothes, and a general air of elegant sophistication. The good captain would undoubtedly have appreciated our noticing.

Notes

1 José de Urrutia's military career is discussed in Donald Chipman, *Spanish Texas, 1519–1821* (Austin: University of Texas Press, 1992), 106, 138; and Jesús F. de la Teja, *San Antonio de Béxar: A Community on New Spain's Norther Frontier* (Albuquerque: University of New Mexico Press, 1995), 90 passim.

2 De la Teja, *San Antonio de Béxar*, 137, discusses the economic security of presidio soldiers.

3 A vara was a unit of measure used in Texas, roughly 85 centimeters or 33 inches long. "Testamentary Proceedings for the Settlement of the Estate of Capt. Joseph de Urrutia," Feb. 27–March 8, 1741, Bexar Archives Translations. Reel 2, vol. 13. Trans. Malcom D. McLean (Austin: University of Texas, 1947), 19–28.

4 Donna Pierce and Cordelia Snow, "Hybrid Households: A Cross Section of New Mexican Material Culture," in *Transforming Images: New Mexican Santos In-Between Worlds*, ed. Claire Farago and Donna Pierce (University Park: Pennsylvania State University Press, 2006), 101.

5 "Testamento del difunto Juan José Flores de Abrego," Bexar Archives Microfilm (Spanish), April 10–26, 1790, reel 020:0315–17.

6 Pierce and Snow, "Hybrid Households," 103.

7 Amy Meschke, "Women's Lives through Women's Wills in the Spanish and Mexican Borderlands: 1750–1846" (PhD dissertation, Southern Methodist University, 2004), 145–46.

8 See Mardith Schuetz, "Professional Artisans of the Hispanic Southwest," *The Americas* 40:1 (1983): 17–71.

9 Schuetz, "Professional Artisans," 35, lists eleven masons active in San Antonio in the eighteenth century.

10 Schuetz, "Professional Artisans," 31.

11 "Settlement of the estate of Don Fernando de Beramendi," 1783, Bexar Archives Translations, reel 14, vol. 118, trans. Kathy Corbett (Austin: University of Texas, 1975), 17.

12 Mitchell A. Codding, "The Decorative Arts in Latin America, 1492–1820," in *Arts in Latin America, 1492–1820*, ed. Joseph Rishel with Suzanne Stratton-Pruitt (New Haven: Yale University Press, 2006), 110.

13 Clara Bargellini, "El coleccionismo estadunidense," in *México en el mundo de las colecciones del arte*, ed. María Luisa Sabau García, vol. 2, *Nueva España* (Mexico City: Grupo Azabache, 1994), 296.

14 "Testamento del difunto Juan José Flores de Abrego," Bexar Archives Microfilm (Spanish), April 10–26, 1790, reel 020:0315–17.

15 The Dallas Museum of Art's *petaca* represents the trials and tribulations of a love triangle.

16 *Gazeta de México*, vol. 1, no. 1 (January 14, 1784): 6.

17 "Embargo of goods of Gov. Angel de Martos," 1767, Bexar Archives Translations, reel 2, vol. 42, trans. Mary Estes (Austin: University of Texas, 1965), 130; and "List of goods given by Manuel González de Texada to Francisco de los Reyes and Francisco Bernal," 1768–69, Bexar Archives Translations, reel 7, vol. 47, trans. Carmela Leal (Austin: University of Texas, 1962), 26.

18 "Will of the deceased Don Juan Jose Flores de Abrego," 1779, Bexar Archives Translations, vol. 82, trans. Patricia Flores (Austin: University of Texas, 1971), 25.

19 Beramendi inventory, 23–24.

20 "Accounting Book Belonging to Don Marcos Vidal," 1773, Bexar Archives Translations, reel 8, vol. 55, trans. Magdalena Sumpter (Austin: University of Texas, 1965), 97–123.

21 *Gazeta de México* 1:11 (February 6, 1784): 93.

22 "Testamentary Proceedings for the Settlement of the Estate of Capt. Joseph de Urrutia," Feb. 27–March 8, 1741, Bexar Archives Translations, reel 2, vol. 13, trans. Malcom D. McLean (Austin: University of Texas, 1947), 22.

23 Jorge Juan and Antonio de Ulloa, cited in Dilys E. Blum, "Textiles in Colonial Latin America," in *The Arts in Latin America 1492–1820* (Philadelphia: Philadelphia Museum of Art, 2006), 153.

24 "Lawsuit Conducted Against Marcos Vidal," 1776, Bexar Archives Translations, reel 8, vol. 55, trans. Magdalena Sumpter (Austin: University of Texas, 1963), 32 passim.

25 Veramendi is discussed in De la Teja, *San Antonio de Bexar*, 133–34.

26 "Settlement of the estate of Don Fernando de Beramendi," 1783, Bexar Archives Translations, reel 14, vol. 118, trans. Kathy Corbett (Austin: University of Texas, 1975), 20–24.

27 "Inventory of Goods of Vicente Albares Travieso," 1784, Bexar Archives Translations, reel 4, vol. 29a, trans. Carmela Leal (Austin: University of Texas, 1963), 65.

28 Meschke, "Women's Lives," 2.

29 "Inventory of Goods of Juan José Flores Abrego," 1779, Bexar Archives Translations, reel 10, vol. 82, trans. Patricia Flores (Austin: University of Texas, 1971), 51.

30 Jacinto Quirarte, *The Art and Architecture of the Texas Missions* (Austin: University of Texas Press, 2002), 153.

31 Clara Bargellini, "Objetos artísticos viajeros: ¿cuáles, cómo, y por qué llegaron al Nuevo México," in *Actas del Primero Coloquio Internacional El Camino Real de Tierra Adentro 1995* (Mexico City: Instituto Nacional de Antropología e Historia, 2000).

32 Juan de Viera cited in Gauvin Bailey, "Asia in the Arts of Colonial Latin America," in Rishel, *Arts in Latin America*, 58.

33 "Inventory of Goods of Juan José Flores Abrego," 50.

34 Gustavo Curiel, "Los biombos novohispanos: escenografías de poder y transculturación en el ámbito doméstico," in *Viento detenido: Mitologías e histrias en el arte del biombo. Colección de biombos de los siglos XVII al XIX de Museo Soumaya* (Mexico City: Museo Soumaya, 1999), 14.

35 Marita Martínez del Rio de Redo, "Los biombos en el ámbito doméstico: Sus programas moralizadores y didácticos," in *Juegos de ingenio y agudeza: La pintura emblemática de la Nueva España*, exhib. cat. (Mexico City: Patronato del Museo Nacional de Arte, 1994), 133.

36 Curiel, "Biombos," 19.

37 Colonial art historian Donna Pierce explains that this seating practice caused Anglo-Americans and other non-Hispanic visitors to Latin American and Spanish homes to view the owners as poor and uncivilized. This was compounded by the Spanish tradition of limited furniture. See Pierce and Cordelia Snow, "A Harp for Playing: Domestic Goods Transported over the Camino Real," in *El Camino Real de Tierra Adentro*, vol. 2 (Santa Fe, N.M.: Bureau of Land Management, 1999).

Sweet Potatoes and Cicero: Furniture and Furniture-Making in the German Settlements of Texas

Lonn Taylor

In 1854, the landscape architect and journalist Frederick Law Olmsted, traveling through Texas to write a series of articles on slavery for the *New York Times*, was astonished to stumble on a colony of German pioneers in the hills north of San Antonio. He was entertained there by a justice of the peace, who, he wrote, "had been a man of marked attainments at home (an intimate associate of Humboldt and a friend of Goethe's Bettina) and kept up here a warm love of nature. His house was the very picture of good-nature, science, and backwoods. Romances and philosophies were piled in heaps in a corner of the logs, and a bookcase was half filled with volumes of Cicero and half filled with sweet potatoes. A dozen guns and rifles and a Madonna in oil, after Murillo, filled a blank on the wall. Deerskins covered the bed, clothes hung about upon antlers, snakeskins were stretched to dry upon the bedstead, barometer, whiskey, powderhorns, and specimens of Saxony wool occupied the table." Dinner in this home, Olmsted said, "was Texas, of cornbread and frijoles, with the coffee served in tin cups, but the salt was Attic, and the talk was worthy of golden goblets."[1] A century and a half later, visitors to the Texas Hill Country are sometimes surprised to go into a café and hear a group of old men wearing blue jeans, cowboy boots, and Stetson hats playing dominoes and speaking German to each other.

Detail, fig. 3

I first encountered the astonishing persistence of German culture in Texas thirty-five years ago, when I was asked by Miss Ima Hogg to become curator of the collection of Texas-German furniture that she had assembled and presented to the University of Texas at Austin. The collection was not housed in Austin, but on a nineteenth-century farmstead called Winedale (now the University of Texas at Austin Center for American History's Winedale Historical Center) halfway between Austin and Houston, near the tiny town of Round Top. My wife and I were the only people in the community who did not grow up in a German-speaking household. The young man who operated the country store across the road from Winedale was several years my junior; his great-grandfather had immigrated to the area from Germany in the 1850s, and his family had once owned the farm that was now the museum. One afternoon he remarked to me that he did not learn to speak English until he started to school in the first grade. I said to him, "Rollie, how could that be? You were born here, you heard English on the radio, it was all around you." It was very simple, he explained. "My father said that German was the mother language, and that I should learn German first. Every time I said a word in English he hit me." I knew his father, who had a somewhat authoritarian personality, and I believed every word of what Rollie told me.

How did this large German population end up in Texas, a state that we tend to associate more closely with ranches, cows, and cattle drives than with beer and sauerkraut, or other such vestiges of German culture? The answer lies in the political and economic conditions of Germany in the 1820s and 1830s, and in the fact that Texas was then part of Mexico, and had a more generous land-granting policy than the United States. Economic conditions in Germany were terrible. There were many, many hungry and dissatisfied people in Germany during those years, and their answer to their circumstances was to emigrate and build a life elsewhere. The result was one of the greatest mass migrations in European history, called in Germany the *Auswanderung*. Between 1830 and 1855 about three million people left Germany. They went not only to Mexico and the United States but also to Hungary and the Ukraine and Australia, and to Brazil, Argentina, Chile, and Canada.[2]

What kind of people left Germany to come to Texas? The great *Auswanderung* was primarily a movement of the lower-middle classes. The small farmer wanted to emigrate because overpopulation and the continual subdivision of agricultural land equally among heirs had placed him on the verge of starvation. As Heinrich Ochs, an early settler of Fredericksburg, wrote, "The oft-divided hearth results in

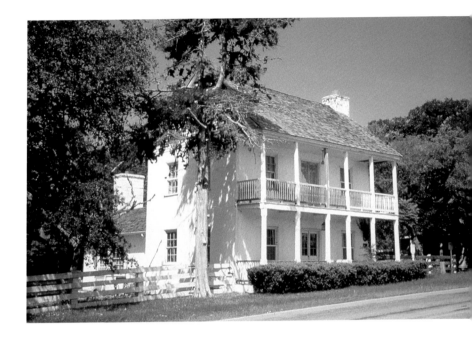

privation.... He who does not desire to remain proletarian and become the father of beggars will take his belongings and seek an opportunity where he and his descendants... can become the holder of an estate and his own home."[3] A small farmer could usually turn what little land he had into cash to finance his immigration, and land was plentiful and cheap in America. It is no surprise that the largest number of German immigrants to Texas were farmers.[4]

A sizable minority were craftsmen—cabinetmakers, shoemakers, blacksmiths, weavers, and other village artisans. The end of the Napoleonic Wars flooded Europe with cheap English factory-made goods, and the next fifteen years saw the introduction of the factory system into Prussia itself. The restrictive guild system, which limited the number of people who could practice a craft in any given place and set standards for their products, was crumbling under pressure from the factory owners. In addition, the removal of customs barriers between the independent German states through the German Customs Union meant the alteration of many protected

Fig. 2. The Fachwerk house built in La Grange in 1852 by John C. Stiehl.

local economies and the displacement of many artisans.[5] The great-grandfather of my German-speaking friend at Winedale had been a shoemaker in Silesia, and when he registered his cattle brand in Fayette County, Texas, in 1856 he drew a profile of a shoe in the brand book, and just so there would be no mistake he wrote the words "This is a shoe" beside it.

A very small minority of the Germans who came to Texas were intellectuals, students, and minor aristocrats fleeing political persecution. Although small in number, these people tended to become community leaders and taste-setters, and they gave the Texas-German settlements the tone that Olmsted noticed when he commented on the volumes of Cicero beside the sweet potatoes. They were called *Lateiner* (or Latin speakers, because of their devotion to the classics) by the other settlers, and some tiny communities such as Bettina, founded by forty students from the University of Geissen, and Cat Spring, settled by twenty-five members

of the aristocratic Von Roeder family and their servants, are still remembered as *Lateiner* settlements. Their inhabitants were known to their less aristocratic neighbors as *Buchbauern*, or book-farmers, as opposed to *Speckbauern*, bacon farmers.[6]

Germans came to Texas through two different types of immigration processes: as individuals or families joining relatives or friends who had gone before them; or as members of a colonization company, with their transportation and settlement arranged by the organization. The earliest settlers were in the first category. The first German family in Texas seems to have been that of Frederich Ernst, a bookkeeper from the Grand Duchy of Oldenburg, who in 1831 was on his way to join a German community in Missouri. In New Orleans he saw a handbill about Stephen Austin's colony in Texas, and learned that under the Mexican colonization laws he and his family could acquire 4,440 acres of land in Texas—more land than many German princes could claim. He went to Texas and built a house on the banks of Mill Creek, in the valley of the Brazos River, on the western edge of Austin's Colony, and then laid out a town called Industry around it. He wrote a letter back to a newspaper in Oldenburg, describing Texas as having "a climate like Sicily"; the letter was reprinted and circulated all over Germany, and soon more families began to arrive. They wrote to friends and relatives, extolling the fertile soil, the mild climate, and the lack of feudal restrictions—"free hunting and fishing for everyone" was a common refrain in these letters—and the trickle became a flood. By 1850 there were several hundred German families in the valleys of the Colorado and Brazos rivers, most of them on small farms interspersed between the larger landholdings of Southern Anglo slave-owners or in the small towns like Bellville, Brenham, and La Grange that served as rural trade centers, all of them part of a growing economy that thrived on the rising price of cotton. This is a region of fertile, rolling country interspersed with creeks and groves of live oak trees; it was truly a paradise.[7]

By 1842, Texas was so well-known in Germany that a philanthropic society of wealthy, titled German nobles called the *Verein zum Schutze deutscher Einwanderer in Texas* (Society for the Protection of German Immigrants in Texas) was established to promote emigration from Germany to Texas. The *Adelsverein*, or "Noblemen's Society," as it was known, bought a tract of land in western Texas and between 1844 and 1846 shipped 7,000 immigrants there under the supervision of Prince Carl of Solms-Braunfels, who briefly came to Texas in 1844 and 1845 to supervise the enterprise and establish the town of New Braunfels, just northeast of San Antonio. His successor as commissioner-general of the *Adelsverein*, Baron

Fig. 3. Louis Hoppe. **Joh. Leyendecker's Farm-Haus bei Frelsburg, Colorado-County, Texas.** *c. 1863. Watercolor. The Witte Museum, San Antonio, Texas.*

Fig. 4. Friedrich Richard Petri. **Farmstead near Fredericksburg, Texas.** *c. 1855. Pencil sketch. UT TMM Collection, Center for American History, University of Texas at Austin.*

Fig. 5. Friedrich Richard Petri. **Flailing Grain.** *Detail. c. 1855. Pencil sketch. UT TMM Collection, Center for American History, University of Texas at Austin.*

Hans Ottfried von Meusebach, founded the town of Fredericksburg sixty-five miles northwest of New Braunfels in 1846. Both of these settlements were on the Comanche frontier, in the semiarid Hill Country region, where the only cultivable soil is in narrow creek valleys between the bare limestone outcroppings of the Edwards Plateau. It was not a hospitable region, and driving across it today it is impossible not to admire the tenacity of those German pioneers.[8]

By 1860 there were about thirty thousand Germans in Texas. Immigration continued to increase after the Civil War, and by 1880 there were more than one hundred fifty thousand German Texans. There was a large concentration of them in the Brazos and Colorado valleys, around Brenham, Bellville, La Grange, and Columbus, and a somewhat smaller one in the New Braunfels and Fredericksburg areas of the Hill Country to the west, and an even smaller one in a third area along the route from the coast to the Hill Country, around Cuero and Yorktown. Today those three regions remain the places where German settlement is most evident.[9]

The first Texas Germans were by no means a homogeneous group. They came largely from the Middle and High German provinces of Nassau, Electoral Hesse, Hesse-Darmstadt, Thuringia, and Wurttemburg, as well as from the Low German Oldenburg, southern Hannover, Braunschweig, Munsterland, and Mecklenburg. In fact, only minor portions of the German-speaking lands contributed settlers to Texas, but these portions were spread over a very large area and differed considerably from each other in many ways. Although most of the immigrants were Lutheran, there were sizable numbers of Catholics and a distinct minority of free-thinkers. In Texas these diverse settlers blended together to form a distinct *Deutscher-Texaner* culture.[10]

A large proportion of the Germans who came to Texas were artisans and craftsmen, and so they had a great influence on the material culture of the regions where they settled. Their most visible and most enduring influence was on the built environment, in the form of the houses, barns, churches, and public buildings that they built for their fellow settlers. Although the most common form of housing in Texas in the 1840s and 1850s was the Southern Anglo-American log house, called a *Laxhaus* by the Germans, many of the Germans in the Hill Country used the plentiful local limestone to build fine stone houses, many of them with regional German characteristics. Among these was the stone house in Fredericksburg built for cabinetmaker Johann Peter Tatsch, with its enormous kitchen chimney, which

houses a thirteen-foot wide raised hearth and oven. Even in the Brazos-Colorado region, where log and frame houses were much more common, some German builders made use of a local sandstone to build rock houses, such as the large house in Round Top built by a Saxon stonemason, Carl Sigismund Bauer, in the 1850s (fig. 1), or the residence and brewery built at the same period on the bluff above the Colorado River at La Grange by another Saxon, Heinrich L. Kreische. Many German settlers in this region also built log houses, but they tended to chink them with mud, straw, and stone and cover them with siding as soon as they could afford to. In both regions, some German builders employed a building technique known as *Fachwerk*, or half-timbering, in which a timber framework is filled with brick, clay, or rock, and then sometimes plastered over or even covered with wooden siding. This is a northern European building technique that dates from the Middle Ages and was originally developed in the face of decreasing timber supplies in Europe and England. There are at least thirty *Fachwerk* houses left in Texas, most of them built in the very first years of German settlement by carpenters who learned the technique in Germany (fig. 2). They are more or less evenly distributed between the Hill Country and the Brazos-Colorado settlements. The filling material includes brick, limestone, sandstone, adobe, and a wattle-and-daub made from mud and Spanish moss. They are in both urban and rural settings. Perhaps one of the most evocative Texas-German houses was the Johann Leyendecker house, built in the 1840s near Frelsburg, in the Brazos-Colorado region (fig. 3). One side of the house was a log cabin; the other side was *Fachwerk*—a perfect metaphor for Texas-German culture. Unfortunately, it was destroyed by fire about 1980. Certainly the strangest structure in the Brazos-Colorado region is the Simon Pitloviny house, a rammed-earth building built in 1909 by a German-speaking immigrant from Austrian Galicia in a style that is derived from the peasant architecture of that region. Much more typical are the little limestone urban dwelling houses in Fredericksburg. When the Adelsverein laid out Fredericksburg and New Braunfels, the plan was that each settler would receive a half-acre lot in town for his garden and chickens and a ten-acre farm on the edge of town, and would reside on the town lot and go out every day to the farm. This plan was soon abandoned as the cheapness of land and the requirements of grazing led settlers to develop larger farms some distance from town and establish both ranch residences and town residences. German ranch

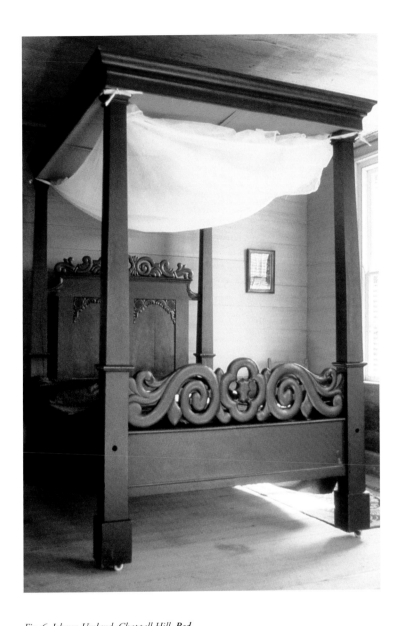

Fig. 6. Johann Umland, Chappell Hill. **Bed**.
1861. Walnut and pine, 93 ¼ x 61 ½ x 84 in.
(236.9 x 156.2 x 213.4 cm). Winedale Historical
Complex, Round Top, Texas.

buildings were frequently laid out like a German farm, with the barn in front of the house and pens, a smokehouse, kitchen, and blacksmith shop forming a compound, rather than strung out behind the house as in Anglo-American ranches. Churches were important buildings, of course, but equally important were the halls that the Germans built for their social organizations: singing societies, agricultural societies, target-shooting clubs, gymnastic societies. The countryside is still dotted with these enormous frame buildings, most of which include a dance floor and stage, a bar, a kitchen, and barbecue pits. Some have additional refinements such as card rooms and bowling alleys. Monthly gatherings at them broke the monotony of farm life. Sociability, or *Geselligkeit,* was—and still is—an extremely important part of Texas-German life, and descriptions of these gatherings occur in many of the memoirs of Texas-German settlers. In 1857 Carl von Iwonski painted one of the weekly meetings of the Germania Gesangverein at their Saengerhalle in New Braunfels, showing the members gathered with their beer and pipes, with sheets of music spread on the table. The halls were also used for amateur theatricals; von Iwonski sketched a production of Schiller's *Kaballe und Liebe* given in the New Braunfels Saengerhalle in June 1856.[11]

Carl von Iwonski came to Texas from Silesia with his parents in 1845, and was among the first settlers of New Braunfels. He was one of several German artists whose sketches and paintings recorded life and material culture on the Texas-German frontier in the 1840s and 1850s. Iwonski actually moved to San Antonio in 1857, and is best known for his portraits of wealthy San Antonians. He did leave us an oil painting of his parents' first home in New Braunfels, showing the log cabin, the corn crib, the haystack with a log base, the wagon, the plow in the field, and himself on horseback in the foreground, and a charming oil painting of a theatrical performance at the German Casino in San Antonio, done in 1858.[12]

Friedrich Richard Petri, born in Dresden in 1824, was much more prolific; at least five hundred of his sketches and paintings have survived (figs. 4, 5). Petri entered the Academy of Fine Arts in Dresden at the age of fourteen, and left the academy in 1849, after having taken part in the revolution against the king of Saxony that year. With his brother-in-law and fellow student Herman Lungkwitz, he decided to emigrate to Texas. In 1852 he and his two sisters, and Lungkwitz and his mother and sister, bought a farm on the banks of the Pedernales River, about five miles southwest of Fredericksburg. They built a log house there, and for the next five years, until his untimely death in 1857, Petri sketched and painted scenes of daily life on the farm. He showed the family flailing grain, shelling corn, and

milking cows. He showed them having afternoon coffee on the porch and going visiting. His sister Elisabet and Adolph Lungkwitz had a daughter, Martha, and then a son named Max, who was the subject of many of his sketches, and later they had twins.[13]

The interiors of Texas-German houses were usually neat and well-furnished. A number of travelers contrasted them favorably with the slovenly dwellings of their Anglo-American neighbors. Since they usually came by ship directly to Galveston, some of the wealthier immigrants from Germany brought a great variety of belongings with them, including furnishings. Their reminiscences are rich with references to barrels of china, pewter plates, walnut furniture, pianos, paintings, mirrors, wheeled plows, mill machinery, and even a flock of Saxon merino sheep, all brought across the water to Texas. Their homes in Texas contained many things that were unfamiliar to their American neighbors. Ottilie Fuchs Goethe remembered that a rumor circulated that her father's family ate off silver plates because they used pewter tableware brought from Germany, and Caroline Mackensen Romberg recalled the incongruity of a huge gilt-framed German mirror, embellished with cherubs, that hung on one wall of her family's log cabin in Bell County. Models brought from Europe existed for the production of similar objects by German craftsmen in Texas, and much of the furniture produced by Texas-German cabinetmakers shows the influence of these models.[14]

Many of the cabinetmakers in the German settlements of the Brazos-Colorado region, between Austin and Houston, were men who had served apprenticeships and done journeyman work in Europe; a few held master cabinetmaker's papers. The Umlands in Chappell Hill were representative of this class. The brothers Johann and Heinrich Umland owned a large and fashionable cabinet shop in Hamburg which was destroyed by fire in 1848. They decided to emigrate to Texas. Heinrich arrived in 1848, purchased land in Austin County, and became a farmer. His brother Johann arrived with their father in 1854 and opened a cabinet shop in Chappell Hill, where several other German cabinetmakers and silversmiths had found a ready market for their products among the local Anglo-American cotton planters. Johann worked with his son Jacob and made furniture there until his retirement in 1881. In 1861 he made a walnut bed, now at the Winedale Historical Center, for a planter named Terrell Jackson (fig. 6). It is a very sophisticated piece of furniture, combining Gothic quatrefoils and Rococo scrolls in a way that is typical of late Biedermeier design in Germany. According to the Jackson family he made two other similar beds for other family members, but they have not yet been discovered.[15]

A few years before the Umlands came to Texas, a wagon-builder and wheelwright named Cristofer Carl Friderich Steinhagen emigrated from the Grand Duchy of Mecklenburg Schwerin to Anderson, Texas, where he set up a shop with a water-powered turning lathe and built wagons, repaired wheels, and made furniture, including a remarkable sofa with a fish rail and swan's-head arms (fig. 7) and a rocking chair with feathered swan's-head arms.[16]

Although marquetry work was popular in Europe and the eastern United States in the 1860s and 1870s, not much seems to have been done in Texas. A two-drawer sewing table from Gonzales, Texas, is an exception. It was made by John William August Kleine in 1866. Kleine emigrated from Prussia in 1853, set up a shop in Gonzales, and made furniture there until about 1875, when the arrival of the railroad made it possible to buy imported furniture at reasonable prices; he then opened a furniture store and was the town's leading furniture dealer until his death in 1900. He served in the Confederate army, and he made the table as a present for his wife when he returned from the war in 1865. It is mahogany, pine, rosewood, and pecan, and it illustrates that Texas cabinetmakers were not limited to local woods, but could buy imported woods even before the railroads made them cheaper. This is confirmed by newspaper advertisements.[17]

Fig. 7. Christofer Friderich Carl Steinhagen, Anderson. **Sofa.** *c. 1860. Oak and pine, 42 x 84 x 25 in. (106.7 x 213.4 x 63.5 cm). Winedale Historical Complex, Round Top, Texas.*

Fig. 8. Unknown maker, Round Top.
Wardrobe. *c. 1850. Cedar, 80 ½ x 64 x 24 in.*
(204.5 x 165.1 x 61 cm).

Fig. 9. Johann Peter Tatsch, Fredericksburg.
Wardrobe. *c. 1860–70. Pine, 83 ⅜ x 61 ¾ x
25 ½ in. (212.4 x 156.8 x 64.7 cm).*

Fig. 10. Johann Michael Jahn, New Braunfels.
Corner Cupboard. *c. 1860. Mahogany veneer and pine,*
60 ¼ x 37 ½ x 25 ½ in. (153 x 95.3 x 64.8 cm).

Fig. 11. Johann Michael Jahn, New Braunfels.
Side Chair. *c. 1870. Walnut, 33 ½ x 18 x 16 in.*
(85.1 x 45.7 x 40.6 cm).

Fig. 12. Johann Michael Jahn, New Braunfels.
Rocking Chair. *c. 1860–70. Walnut and pine,*
42 ¼ x 24 ¼ x 20 3/8 in. (107.3 x 61.6 x
51.8 cm). New Braunfels Conservation Society,
New Braunfels, Texas.

Not all German cabinetmakers in the Brazos-Colorado region made expensive furniture for wealthy clients, but most of the furniture they made was well built and reflected a knowledge of contemporary European fashion. A little sewing table from Round Top is a case in point. Its rounded corners, flared legs, and concealed drawer divided into four compartments, are quite sophisticated and show a familiarity with the Biedermeier style. We don't know who made it, but it was acquired by the prominent collector Faith Bybee in Round Top and has a penciled inscription on the bottom that reads "Zum Hochzeits Geschenk fur Hulda Franke"— a wedding present for Hulda Franke—" 25 October 1873." Little sewing tables like this, with rounded corners and flared Biedermeier legs, were quite common, and in German households they were often placed, along with a chair, on a little platform by a window in order to get the handwork as close to the light as possible. They are evocative of the central place sewing and handwork occupied in women's lives at the time.[18]

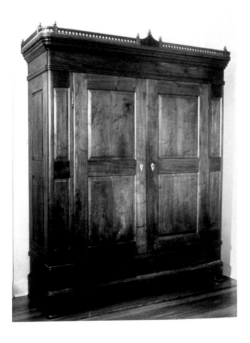

Fig. 13. Franz Stautzenberger, Clear Spring.
Wardrobe. *1861. Walnut and pine, 90 ½ x 75 x 26 ⅝ in. (229.8 x 190.5 x 67.6 cm).*

Another very important piece of furniture in Texas-German households was the *Kleiderschrank*, or wardrobe, in which clothes were hung or folded in the drawers below. This is a furniture form that is probably more important in German and Dutch tradition than in the English and American, and eighteenth-century European examples are often elaborately ornamented. These were usually the largest pieces of furniture in the house, and since they were often kept in upstairs bedrooms they were made to be disassembled and carried up the stairs in pieces. *Kleiderschranks* from the Brazos-Colorado region often exhibit both superb craftsmanship and a mastery of current styles on the part of their makers. The bobbin turnings on the front corners and under the tops of several wardrobes found in farm houses around Round Top indicate that their unknown maker was familiar with the Elizabethan Revival style (fig. 8). By contrast, another wardrobe collected in Round Top is beautifully constructed but has a very strong eighteenth-century feeling, with raised panels and rectangular feet; its Neoclassical urn finials and somewhat fanciful crest set it off from other examples from that area. These wardrobes were probably

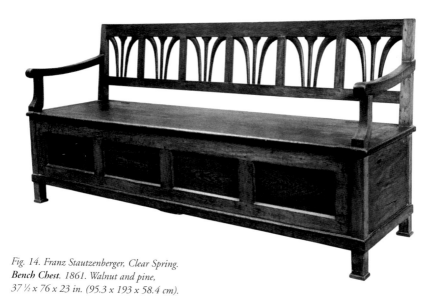

Fig. 14. Franz Stautzenberger, Clear Spring.
Bench Chest. *1861. Walnut and pine,*
37 ½ x 76 x 23 in. (95.3 x 193 x 58.4 cm).

originally painted; another example from Round Top is a nice chocolate brown with black trim, perhaps suggesting mahogany and ebony. They were provided with swinging arms and hooks inside; one at Winedale has twenty hooks.[19]

Wardrobes, French beds, and side chairs from the Hill Country also show magnificent craftsmanship and the same awareness of contemporary style that is found in the Brazos-Colorado region, but that is totally lacking in other parts of Texas, where most furniture was made in the Plain Grecian style up through the 1870s. Four wardrobes made in Fredericksburg in the 1860s by Johann Peter Tatsch demonstrate his familiarity with current furniture fashions. The broken pediment on three of them is characteristic of Renaissance Revival style (fig. 9), while the twisted columns on the fourth were described by Andrew Jackson Downing in 1850 as "a largely used feature of Elizabethan furniture." At the same time the pointed ovals on the drawers show that Tatsch was familiar with Neoclassical design vocabulary, and the geometric elements on each side of the drawers have a Gothic quality, giving the entire piece the eclectic combination

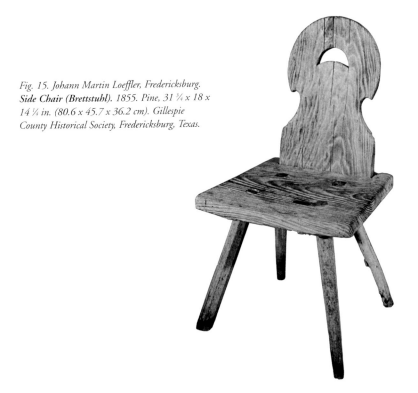

Fig. 15. Johann Martin Loeffler, Fredericksburg. **Side Chair (Brettstuhl).** *1855. Pine, 31 ¾ x 18 x 14 ¼ in. (80.6 x 45.7 x 36.2 cm). Gillespie County Historical Society, Fredericksburg, Texas.*

of historical styles that was popular in Europe and the East in the 1860s. A walnut wardrobe by Johann Jahn of New Braunfels is purer in style but equally sophisticated and demonstrates the ease with which Jahn worked in the Biedermeier style popular in Germany in the 1830s and 40s, as does a bow-front mahogany veneer cupboard made by him (fig. 10), and his elegant walnut side chairs (fig. 11), rocking chairs (fig. 12), and sewing tables. Jahn was not the only cabinetmaker in the Hill Country who made elegant walnut side chairs, as examples by Heinrich Scholl of New Braunfels and Jacob Schneider of Fredericksburg attest. Schneider's descendants in Fredericksburg have not only preserved a set of six walnut klismos chairs that he made for his own use but also the shaped block of walnut from which the back stays were sawn.[20]

There are two factors responsible for this sophistication. First, most of the German cabinetmakers were trained in a much more rigorous and demanding system than their Anglo-American counterparts. Johann Jahn, for instance, left his native Pomerania at the age of fourteen and served a five-year apprenticeship in Prague and then worked for several years as a journeyman in Switzerland before being awarded his master cabinetmaker's papers and emigrating to Texas in 1844. Franz Stautzenberger of Clear Spring, near New Braunfels, served the same kind of apprenticeship and worked at the court of the Grand Duke of Nassau before he came to Texas and made a beautiful walnut wardrobe as a wedding present for his nephew Conrad Oelkers, whose initials he carved on the central cartouche (fig. 13). Stautzenberger also made a beautiful bench-chest, with an Egyptian Revival back (fig. 14). The European system of apprenticeship simply produced better-trained cabinetmakers than the American system, which allowed cabinetmakers to set up shop as soon as they could satisfy enough customers not to go broke. The second factor is more elusive, but I think it is equally important. Germany in the first half of the nineteenth century had a very rigid class system, in which the outward manifestations of social class were extremely important markers of status. Furniture was one of those markers. Middle-class people had one type of furniture, and peasants had another type, called *Bauermoebel*. It would have been unthinkable for a peasant, even a wealthy one, to furnish his house in the same way that a member of the professional class would. Although the largest group of immigrants to Texas were from the peasant class, a *Brettstuhl* made by Johann Martin Loeffler in Fredericksburg in 1855 (fig. 15), and a somewhat modified one made in Cat Spring at about the same time are some of the very few examples of German

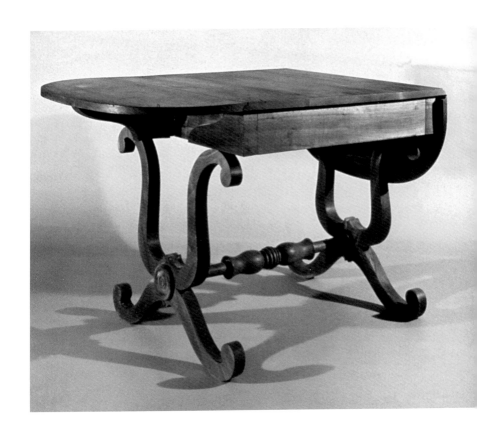

Fig. 16. Englebert Krauskopf, Fredericksburg.
Sofa Table. c. 1860. Walnut and pine, open:
30 ⅞ x 33 ½ x 60 ¾ in. (78.4 x 81.5 x
154.3 cm); closed: 30 ⅞ x 33 ½ x 23 in.
(78.4 x 81.5 x 58.4 cm).

peasant furniture made in Texas. I think that is because in Texas-German class restrictions were enthusiastically rejected by peasant immigrants, and along with them they rejected furniture forms that were badges of inferior status. They demanded middle-class forms, and Texas-German cabinetmakers responded by producing them in great numbers.[21]

Another striking characteristic of the nineteenth-century Texas-German cabinetmakers, in addition to their sophistication, is the carefully circumscribed scale of their operations. According to the 1860 Products of Industry census returns, Gillespie County, of which Fredericksburg is the county seat, was one of nine counties in Texas where more than $3,000 worth of furniture was manufactured that year. In the other eight counties this high level of production was achieved by one or two shops using steam-powered or at least horse-powered machinery and employing three to six hands. In Gillespie County there were ten cabinet shops, all in Fredericksburg, each operated by only one man using only hand tools, and each producing between $500 and $1,500 worth of furniture annually. There were at least three other Gillespie County cabinetmakers who kept shops in Fredericksburg or on their farms who did not make enough furniture to be listed on the Products of Industry census returns. This means that in the late 1850s Fredericksburg, with a population of about one thousand five hundred, had more cabinet shops than any other city in Texas, and they were essentially German village shops.[22]

The same phenomenon can be seen, though not as strikingly, in New Braunfels and in the towns of the Brazos-Colorado region further east. These shops must have been very small indeed. As in Germany, they were frequently just a room or the corner of a room in the cabinetmaker's house. Johann Martin Loeffler, a native of Wurttemberg who came to Fredericksburg in 1859, lived with his family in a two-room log house which also housed his workshop. Johann Peter Tatsch of Fredericksburg made his wardrobes and other furniture in a shed behind his house. Heinrich and Adam Scholl, New Braunfels cabinetmakers, worked in a room behind their mother's house. Their tools have been preserved by their descendants and are the traditional tools of the German cabinetmaker: a sliding-catch carpenter's bench, a twelve-foot long foot-treadle lathe, and a set of planes, saws, augers, and chisels. Some cabinetmakers fashioned their own tools. Ferdinand Schulze of Fredericksburg, who was an individualist in many things (he was known as *Sontag Schulze* because he was a freethinker and took great delight in being seen busy in his shop on Sunday mornings) built his own workbench from cypress and pecan

Fig. 17. Eugen Benno Ebensberger, New Braunfels.
Desk. *c. 1870. Walnut and pine, 80 ¼ x 52 ⅞ x*
31 ¼ in. (205.1 x 139.4 x 79.8 cm). New Braunfels
Conservation Society, New Braunfels, Texas.

Fig. 18. William Arhelger, Fredericksburg.
Sewing Table. *1863. Walnut and pine,*
26 ¼ x 14 x 16 ⅛ in. (66.7 x 35.6 x 41 cm).

Fig. 19. William Arhelger, Fredericksburg.
Center Table. *c. 1870. Walnut and pine,*
29 ¾ x 36 in. (diam.) (75.6 x 91.4 cm).

and even fashioned the dogs, which are the pegs that hold the wood fast to the bench and which are usually made of iron, from cypress. The smaller hand tools were almost always brought from Germany in a cabinetmaker's chest, several of which survive in museums in the Hill Country. Cabinetmaker's planes from Germany can be easily identified because they are on the Northern European pattern, with a wooden horn to be gripped by the left hand on the front.[23]

The Texas-German cabinetmakers tended to work primarily in local hardwoods, gathered from the hardwood forests that lined the river and creek bottoms. As might be expected, walnut, cedar, and in the Hill Country, cypress predominate in their furniture. Johann Peter Tatsch's grandchildren remembered that he went into the woods with a cart to cut and haul back walnut and cherry, which he then cured in his backyard before using. They also recalled that "he favored a light, hard hackberry for rawhide bottom chairs" and made at least one bed from hackberry. In both the eastern and western settlements the local wood supply was sometimes supplemented by imported mahogany hauled from Galveston or pine from the Bastrop pine forest, an island of pine that lies between the two regions, but the great majority of Texas-German furniture that has survived is made of walnut. An old cabinetmaker in Round Top once told me that he loved working in walnut because "it cuts just like butter."[24]

As in most frontier cultures, German cabinetmakers in Texas were versatile and were willing to put their hands to all sorts of tasks besides making furniture, although few were as versatile as Englebert Krauskopf of Fredericksburg. Krauskopf was a native of the Prussian Rhine Province, where he was trained as a cabinetmaker. He was among the original settlers of Fredericksburg and was employed by the Adelsverein as a hunter to provide meat for the settlers. He opened a cabinet shop, and at least one beautiful and highly sophisticated sofa table he made by still exists (fig. 16). He also built and operated a sawmill and a cotton gin, and was an accomplished gunsmith. In the mid-1850s he turned to full-time gunsmithing, and his rifles are highly treasured by collectors.[25]

Many cabinetmakers made coffins, and several advertised the speed with which they could build a coffin, an essential in a hot climate. They also lined coffins, built the cases, frequently kept a hearse on hand, and offered all the services of undertakers. It is interesting that many children and grandchildren of Texas cabinetmakers became undertakers. A good Hill Country example is that of Eugen Benno Ebensberger of New Braunfels who not only built beautiful desks (fig. 17) but marked them with a label that said "Manufacturer of Furniture…Coffins on Hand or Made to Order."

Ebensberger's grandson used to operate the Ebensberger Funeral Home in Boerne, Texas. But Texas-German cabinetmakers branched out into many other fields in addition to undertaking. James August Lemons, an Adelsverein colonist of New Braunfels, built a ferryboat for the Comal County commissioners in 1849; twenty years later another cabinetmaker, Charles Floegge, replaced it with a bridge. Gottfried Buescher of New Ulm not only produced $1000 worth of furniture in 1870; in 1876 he signed a contract to build a carousel with "twenty wooden horses and two buggies" for $550. Heinrich Scholl in New Braunfels not only made rocking chairs and beautiful inlaid tables—his obituary ends with the words, "there is not one who could build an inlaid table as beautifully as Heinrich Scholl"—but he also made window sashes, doors, and outside molding for houses. Some of the most beautiful Hill Country furniture was made by a man who was both a cabinetmaker and wheelwright, William Arhelger. Arhelger came to Texas at the age of eight, in 1845. He was apprenticed to a German wheelwright and cabinetmaker in the nearby town of Boerne to learn both trades, and when he finished his apprenticeship he made a sewing table for his fiancée, Katherina Gruen. In his shop in Fredericksburg he built farm wagons, hacks, and buggies, and made some of the most beautiful Texas-German furniture, including a bois d'arc and walnut spool bed, a sewing table (fig. 18), a crib, and a round walnut center table with stylized double-lyre supports (fig. 19).[26]

In closing, I'd like to examine one more object, an artifact which speaks clearly about cultural persistence. A folk toy called a *pyramide*, made of wood and papier-mâché and about three feet tall, is part of the Winedale Collection (fig. 20). It was made in Fayette County, Texas, in the 1870s by an immigrant from Saxony named Emil Schuhmann. When the oil lamps attached to it are lit the heat rising from them turns a fan on top, which in turn rotates three platforms with carved figures on them through a domed building. Miners with picks and carts of ore move through the base on the first level, soldiers rotate on the second, and bandsmen on the third. This was a very common form of toy in the Erzgebirge region of Saxony, where miners carved them to supplement their incomes, and that is where Emil Schuhmann was from. Mr. Schuhmann was a bachelor, and every year at Christmas he would set the *pyramide* up in his house and invite the local

children to come and see it. He would light the lamps and then sit behind it and play music on his accordion. It is made out of German-language Galveston newspapers from the early 1870s. It was still being set up every Christmas by Mr. Schuhmann's niece, and children were still coming to see it, when Miss Hogg purchased it for Winedale in the early 1960s.[27]

The accordion music has faded away and the nineteenth-century Texas-German cabinetmakers are long in their graves, but while they lived they made some beautiful furniture.

Fig. 20. Emil Schuhmann, Waldeck. **Christmas Toy (Pyramide).** *c. 1875. Papier-mâché and wood. Winedale Historical Complex, Round Top, Texas.*

Notes

1 Frederick Law Olmsted, *Journey Through Texas: A Saddle-Trip on the Southwestern Frontier*, ed. James Howard (Austin: Von Boekman-Jones Press, 1962), 108.

2 Mack Walker, *Germany and the Emigration, 1816–1885* (Cambridge, Massachusetts: Harvard University Press, 1964), 175–81; Terry Jordan, *German Seed in Texas Soil* (Austin: University of Texas Press, 1966), 32–33.

3 Gillespie County Historical Society, *Pioneers in God's Hills* (Austin: Von Boeckmann-Jones, 1960), 153.

4 Walker, *Germany and the Emigration*, 3.

5 Walker, *Germany and the Emigration*, 2.

6 Rudolph Leopold Biesele, *The History of the German Settlements in Texas, 1831–1861* (Austin: Von Boekman-Jones, 1930), 48–50, 64, 154–57; August Siemering, "Die Lateinische Anseidlung in Texas," *Texana* 5 (1967): 126–31.

7 Biesele, *German Settlements*, 43–46.

8 Ibid., 102–119; 139–41.

9 Jordan, *German Seed*, 48–59.

10 Ibid., 32–33.

11 Lonn W. Taylor, "Fachwerk and Brettstuhl: The Rejection of Traditional Folk Culture," in *Perspectives on American Folk Art*, ed. Ian Quimby and Scott Swank (New York: W. W. Norton & Company, 1980), 170–71; Gerlinde Leiding, "Germans in Texas," in Allen G. Noble, *To Build in a New Land: Ethnic Landscapes in North America* (Baltimore: The Johns Hopkins University Press, 1992), 369–74; James Patrick Maguire, *Iwonski in Texas: Painter and Citizen* (San Antonio: San Antonio Museum Association, 1976), 67, 74.

12 McGuire, *Iwonski in Texas*, 11–12, 37, 41.

13 William W. Newcomb, Jr., *German Artist on the Texas Frontier: Friedrich Richard Petri* (Austin: University of Texas Press, 1978), 5–8, 13–15, 71, 77, 85, 100, 103, 104, 111.

14 See, for instance, Ottilie Fuchs Goethe, *Memoirs of a Texas Pioneer Grandmother (Was Grossmutter Erzaehlt), 1805–1915* (Austin, Texas: n.p., 1969); Rosa Kleberg, "Some of My Early Experiences in Texas," *Quarterly of the Texas State Historical Association* 1 (1898): 170–73; Caroline Mackensen Romberg, *The Story of My Life Written for My Children* (n.p., 1970).

15 Lonn Taylor and David B. Warren, *Texas Furniture: The Cabinetmakers and Their Work, 1840–1880* (Austin: University of Texas Press, 1975), 44–45, 324–25.

16 Ibid., 127, 164, 321.

17 Ibid., 216, 302.

18 Ibid., 188.

19 Ibid., 95, 96, 110.

20 Ibid., 84, 98–101, 150–51, 254–55.

21 Donald L. Stover, *Tischlermeister Jahn* (San Antonio: San Antonio Museum Association, 1978), 9; Taylor and Warren, *Texas Furniture*, 85, 153–54, 174, 321; Taylor, "Fachwerk and Brettstuhl," 172–75.

22 Taylor and Warren, *Texas Furniture*, 333–34.

23 Ibid., 22–23, 304–305, 317, 323.

24 Ibid., 31; Gillespie County Historical Society, *Pioneers*, 213–15.

25 Taylor and Warren, *Texas Furniture*, 218, 302.

26 Ibid., 276, 282–83, 289, 292, 304.

27 Cecilia Steinfeld and Donald Stover, *Early Texas Furniture and Decorative Arts* (San Antonio: San Antonio Museum Association, 1973), 238.

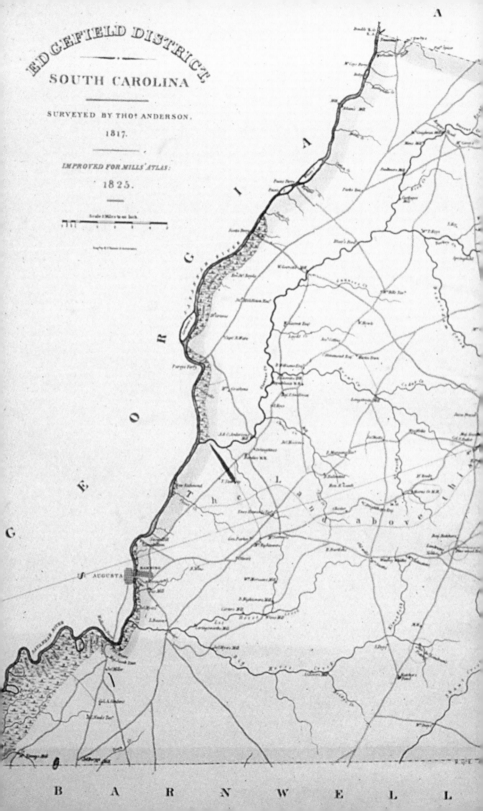

EDGEFIELD DISTRICT

SOUTH CAROLINA

SURVEYED BY THOS ANDERSON.

1817.

IMPROVED FOR MILLS' ATLAS:

1825.

Scale 2 Miles to an Inch

B A R N W E L L

Clay Connections:
A Thousand-Mile Journey from South Carolina to Texas

Jill Beute Koverman

One can visit Edgefield, South Carolina, and stand at the courthouse on the corner of Buncombe and Main streets and imagine what it would have been like to have been there in the early nineteenth century (fig. 1). From the intersection of these two streets, you would have seen a town bustling with political, civic, and commercial activity including the operation of several potteries, as recalled by editor Arthur Simkins in this newspaper article of May 11, 1859: "A clever writer in the South Carolinian discourses of old Pottersville and Dr. Landrum in pleasant terms.... Do we not still mind how the boys and girls used to think it a fine Saturday frolic to walk to old Pottersville and survey its manufacturing peculiaristics? To watch old DAVE as the clay assumed beneath his magic touch the desired shape of jug, jar, or crock, or pitcher as the case might be?"[1]

Almost one hundred fifty years later, a lively discourse continues about Dave, Dr. Landrum, and the others involved in the manufacture of stoneware in and around Edgefield. The tradition that emerged from Pottersville, a small hamlet a mile north of Edgefield proper, is not just one of local, entrepreneurial success but rather encompasses American scientific discovery and ingenuity, skilled craftsmanship, personal endurance, and westward expansion into Texas.

Detail, fig. 3

Fig. 1. View of Edgefield Courthouse Square, 1998.

Hundreds of decorated and undecorated utilitarian pots made by potters from Edgefield have survived into the twenty-first century because of their usefulness, durability, or beauty (fig. 2). Through close examination of extant vessels, one can gather information about the origins and makers of the pots, how they were used, and how they survived. History emerges when we use pottery as a magnifying glass to bring the written documents such as census records, account books, and advertisements into clearer focus. The potters from Edgefield, South Carolina, are the focus of this paper—who they were, who they worked with, what they produced, why they moved, and how "manifest destiny" brought a particular tradition one thousand miles from Edgefield, all the way to Texas. The storage jugs and jars, pitchers, and churns with a distinctive lime or ash glaze were the basis for successful pottery factories from Edgefield to Seguin, Texas, as the potters met the demands of the cotton- and plantation-based agricultural economy.

The town of Edgefield is located twenty-five miles east of the Savannah River, which forms the boundary between South Carolina and Georgia. Geologically, the surrounding area is endowed with rich mineral deposits. It is situated along the Fall Line, which extends westward all the way into Mississippi.[2] The residual clay found above the Fall Line is primarily feldspathic, ranging in color from deep iron red to gray. Kaolin, the main sedimentary clay, is almost pure white. Formed by decomposing feldspar and granite, it is found below the Fall Line. The region is heavily wooded with both hard- and softwoods and intersected by streams and small rivers. These raw materials are all necessary for the manufacture of stoneware pottery and are the main reasons the potteries were established in this area and were successful.

Pottersville, also known as Landrumsville, was situated one mile northeast of the Edgefield courthouse as one travels out Buncombe Street. The small community had many prosperous businesses, including a pottery, a blacksmithing shop, a newspaper, a tannery, and a hotel.[3] Pottersville was part of the larger community made up of Edgefield and the District of the same name. This area became the "Crossroads of Clay," a term coined by folklorist and historian John Michael Vlach to describe the confluence of cultural traditions from Europe, Africa, and Asia in the creation of a unique type of pottery.[4]

The potters from this area came primarily from two cultural groups: artisans of European descent who had migrated from Pennsylvania and Virginia, and those of African descent who came over on the slave ships or were later born into slavery. The Landrums, with their origins in Scotland, migrated down the Great Wagon Road, bringing with them their simple pitchers, and sturdy, bulbous pottery jugs and jars. Samuel Landrum and his family lived in North Carolina and then settled in Edgefield around 1773. There he and his wife raised five sons and a daughter. Three of the sons, John, Abner, and Amos, were joined by their sister Martha's sons, Harvey and Reuben Drake, in the creation of a stoneware dynasty. This endeavor was built upon family connections similar to those found among European potters everywhere. By 1850, the industry reached its zenith in terms of number of factories, production, and financial value through the use of slave labor. The number of factories declined in the 1870s before pottery production all but ended in Edgefield at the beginning of the twentieth century.

Fig. 2. Collin Rhodes Factory. **Pie Pan.** *c. 1850.*
Alkaline-glazed stoneware with kaolin slip,
2 ½ x 9 ¾ in. (6.4 x 24.8 cm). McKissick
Museum, University of South Carolina.

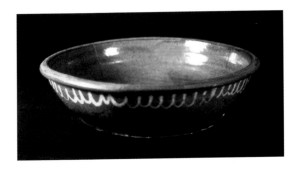

In December 1812, Abner Landrum was granted a loan of $2,000 from the General Legislation of South Carolina to establish a "Quensware or Porcelain" manufactory in Edgefield.[5] Not much is known about this endeavor as there are no extant marked examples of queensware or porcelain wares made at Pottersville. However, by 1817, Abner and his relatives were producing stoneware jugs, jars, pitchers and churns of good quality and selling them to the people of South Carolina. These wares were a low-cost and more durable alternative to soft, lead-glazed earthenware and salt-glazed stoneware. By the end of the eighteenth century, lead was known to be toxic when ingested. Additionally, both lead and salt were expensive to purchase as they were not readily available. It was also less expensive than importing wares from the port of Charleston or from northern cities such as Philadelphia or New York. The wealthy residents of Edgefield did own fine porcelains from China, along with feather-edged queensware and fancifully decorated mocha-wares imported from England. The pottery factories responded to the demand from small and large households, farms, and plantations with pieces that did not need special care and that were durable for everyday use. Hundreds of thousands of stoneware vessels were produced in Edgefield during the nineteenth century.

Scientifically minded and educated as a physician, Abner Landrum has been credited with the development of the alkaline-glaze between 1810 and 1817. Prior to its use in Edgefield, this glaze was not found outside of the Orient—China, Japan, and Korea. It is thought that he was the one who developed the glaze based upon his education and access to Jean-Baptiste Du Halde's *The General History of China*, in which the papers of Pierre d'Entrecolles, including letters regarding the manufacture of china, appeared.[6] The glaze, now called alkaline because of its chemical properties, is composed of lime or wood ash or both, then mixed with local clay and water. It can be fired to a temperature exceeding 2,250 degrees Fahrenheit, the result being a durable, nontoxic surface for stoneware that is inexpensive to create. The coloration of the glaze depends upon the clay and the type of ash or lime, as well as the atmosphere of the kiln.

The Landrum family had at least two potteries operating in the 1810s and 1820s and owned a thousand acres of land in the Edgefield District on Shaw's Creek and another thousand acres on Horse Creek as early as 1808. Two of the brothers were involved in each land transaction. Abner is closely associated with Pottersville—called Landrumsville in 1817 by surveyor Thomas Anderson and then published in Robert Mills's *Atlas of South Carolina* (fig. 3) in 1825. Reverend John

Fig. 3. Thomas Anderson. Map, Edgefield District, South Carolina, from Robert Mills's **Atlas of South Carolina.** *1825.*

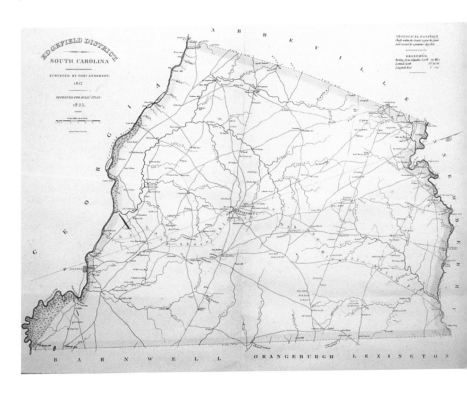

Landrum was identified as the owner of the pottery located south of the Edgefield Courthouse on Horse Creek. Aside from operating the pottery, John was also a circuit-riding preacher. From what is known, Amos worked with his brothers and nephew Harvey in the potteries and had numerous other landholdings.[7]

The early examples of stoneware made at Pottersville and Reverend John Landrum's pottery are generally ovoid in shape, with strap and lug handles, and a light colored glaze. The clay used during this period had a high content of kaolin with little iron. Many of these early jugs and jars were stamped with a single letter near the base—"P," "A," and "S" were found on the shards illustrated in fig. 4. It is likely that the letters were maker's marks based on the initial of the potter. None was signed with a name, and only a few were dated. The vessels were often small in size, no more than five gallons in capacity.

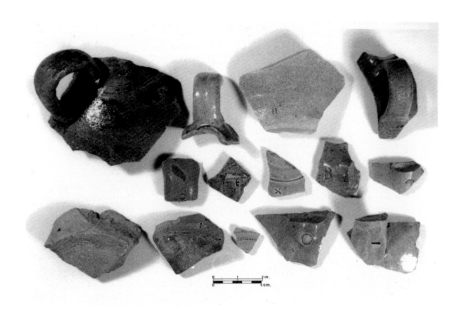

Fig. 4. Rev. John Landrum Pottery. Various shards. c. 1820.
Alkaline-glazed stoneware. McKissick Museum, University
of South Carolina.

Potteries were labor-intensive enterprises. Many hands were needed to dig, haul, refine, and prepare the clay for turning. The skilled workers would turn, glaze, and decorate the vessels before they were fired. Others, less skilled, chopped and hauled wood and loaded and unloaded the kiln. Many would be involved in stoking the kiln fires for two to three days. The wagoners loaded the wagon and hauled the wares to market. Hired white and enslaved black men, along with a few women, worked in the potteries. The potteries often operated year-round, and the work was hard. The days started early, with only Sundays off to rest and to attend religious services.

James Prothro, Cyrus Cogburn, Abraham Massey, Matthew Duncan, James Kirbee, and the Leopards were potters who learned how to make the alkaline-glaze in the 1810s and 1820s. All were associated with the Landrums and lived in Edgefield for a short period of time before leaving to seek their own fortunes in the "Indian nations" of the West. They all continued to produce stoneware of similar forms using the inexpensive glaze and carried the alkaline-glazed stoneware tradition to Texas.

After the War of 1812, many young families from South Carolina went westward looking for better opportunities as the young nation expanded its borders and the Indians were pushed further westward. Of these settlers, many were the sons of planters and yeoman farmers who yearned for their own land and money; others were lawyers and merchants; there were also carpenters, mechanics, and craftsmen who produced utilitarian goods such as cabinets, wagons, iron goods, and pottery. Some historians have estimated that between 1820 and 1850, more than half of the South Carolinians and about twenty-five percent of Georgians migrated to the Old Southwest, that is, to Alabama, Mississippi, and Texas.[8]

Land speculation was one of the main reasons many moved west. On April 9, 1830, South Carolina College President Thomas Cooper wrote to Dr. Cohen of Baltimore, "I begin to think the land speculation in Texas is not worth much. Do you hear any thing of the title, which my correspondent is not much pleased with. I fancy by hook or by crook Texas will belong to the United States."[9] His words were prophetic, as many South Carolinians, including Edgefield natives William Barret Travis and James Butler Bonham, fought and died at the Alamo in 1836.[10] More still would fight in the Mexican War in 1846; Edgefield fulfilled her quota of soldiers at the initial summons.[11]

These men and their families traveled along the many wagon roads. One of the main ones that led from Edgefield and Hamburg into Georgia followed a route similar to present-day Interstate 20. The road, which also followed the Fall Line and its related natural resources of good clay and abundant water supply, traversed Georgia through the capitol of Milledgeville, and then crossed Creek Indian Territory into Montgomery, Alabama. Cogburn and Massey left before 1820, as they were in Washington County, Georgia, at the time of the census. James Kirbee left Edgefield between 1825 and 1830 and moved across the Savannah River to Elbert County Georgia by 1830. The Leopards were in Fayette County, Georgia, in the 1830s, and in Randolph, Alabama, in the 1840s. By the 1850s, all of these men were living in Texas and engaged in pottery manufacture.

A few of the enslaved African Americans working in the potteries between 1810 and 1830 are known. According to Cinda Baldwin, "Seven slaves—Daniel, Sam, George, Abram, Old Harry, Young Harry and Old Tom—were named in records pertaining to the Pottersville factory. Daniel was listed as a turner, and Old Tom as a wagoner."[12] Little is known of these men except for information listed in legal documents and advertisements. Another enslaved African American who worked in the potteries at this time was a young man named Dave. In 1817, at age seventeen, he was used as collateral by Abner Landrum, Amos Landrum,

and Harvey Drake in a mortgage agreement with their neighbor Eldrid Simkins. During his lifetime, Dave was owned by several men, all related, and worked at each of their potteries. It is likely that he encountered or worked with Cogburn, Massey, Prothro, Duncan, Kirbee, and the Leopards. He turned thousands of jars, many of which he signed with his name, "Dave," and an occasional date. On at least thirty occasions, he inscribed poetry on the sides of the pots. His actions provide us with the best documentation of any single potter's work in Edgefield during the period of 1834 to 1864. Dave, who took the last name Drake after Emancipation, was one of more than fifty enslaved men and women who worked in the Edgefield potteries.

A small number of pieces attributed to Dave were produced as early as the 1820s. These include a jug bearing the date 1821 (fig. 5). The attribution to Dave is based on the similarities between this jug and several others dated from the 1830s, where the handwriting is clearly that of the potter (fig. 6 and 7). The glaze coloration, height, and circumference are almost identical in all three instances. These potteries were factories with the goal of producing wares of consistent size, form,

Fig. 5. Attributed to David Drake, Pottersville or Rev. John Landrum Pottery. Jug. 1821. Alkaline-glazed stoneware, 14 ¼ x 12 in. (36.2 x 30.5 cm). Collection of Phil and Debbie Wingard.

and look, but the pots were made by hand, which yielded certain individual idiosyncrasies. During this time, Dave worked at Pottersville for Dr. Abner Landrum, Amos Landrum, and Harvey Drake. Some scholars believed that Dave also worked for Abner at his newspaper, the *Edgefield Hive*, and that may be where he learned to read and write. Abner sold the Pottersville factory to Harvey and Reuben Drake in 1828. Dave was then later owned by Harvey Drake and worked as a turner for Harvey and Reuben Drake until Harvey died in December of 1832. The following year, Reuben Drake and his business partner Jasper Gibbs purchased Dave for $400.[13] Dave continued to work at Pottersville, which was then owned by Drake and Collin Rhodes, Amos Landrum's son-in-law. While the name of the pottery and the roster of owners changed between 1834 and 1840, Dave continued to produce stoneware.[14] By the age of thirty-four, he was a very skilled potter and

began to write poetry on the side of the large jars. "Put every bit all between / surely this jar with hold 14" appears on a large fourteen-gallon vessel, along with the date July 12, 1834.

It was not unusual during the antebellum period for free African Americans to work as craftsmen along with those enslaved in the potteries. In Alexandria, Virginia, another African-American potter named David Jarbour was able to purchase his freedom from Zenas Kinsey in 1820. In 1830, he was creating utilitarian salt-glazed stoneware for Hugh Smith. Jarbour also fashioned large pieces of more than twenty inches in height (fig. 8). Unlike Dave, this potter signed his initial and last name and dated his work on the bottom of the piece.[15]

In March of 1836, Dave incised the poem "Horses, mules and hogs / all our cows is in the bogs / there they shall ever stay / til the buzzards take them away," on the side of an eight-gallon jar, one of the hundreds of vessels he turned that month (fig. 9). This jar eventually made its way to Elberton, Georgia, where it was used

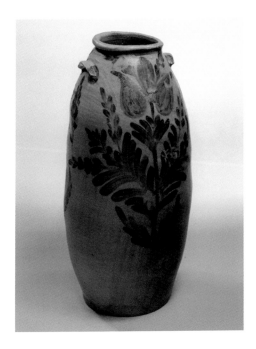

for keeping dry-goods such as flour until 1997. The jar with the poem is very similar in form and size to another four-handled jar that was slip decorated and inscribed "Hiram Gibbs / Union District / S. Cr. / Presented 1836." Most likely, this Hiram Gibbs was seven years of age in 1836, the same young man who would be living with Martin Canfield's family in Bienville Parish, Louisiana, in 1850.[16]

The next ten years were marked by continual change at Pottersville. Nathaniel Ramey became a business partner with Reuben Drake and Collin Rhodes in January 1836; in September of the same year, Drake sold his share of the business to Robert Mathis and the business was renamed Ramey Rhodes and Company. A year later, Reuben Drake and his family left Edgefield and moved to Bienville Parish, Louisiana along with forty other Edgefield families. This may have been a response to the opening of lands in the West effected by the Indian Removal Act of 1830 and the Trail of Tears, as well as a reaction to the economic depression caused by the Panic of 1837, when many banks closed their doors. In 1838, only

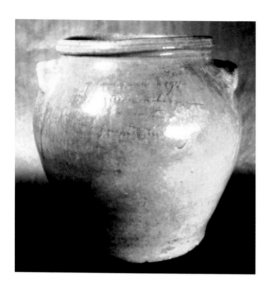

Fig. 9. David Drake, Pottersville, Drake & Gibbs. **Storage Jar.**
*March 29, 1836. Alkaline-glazed stoneware, 19 ¼ x 18 in. (48.9 x
45.7 cm). Incised "Horses, mules and hogs/all our cows is in the bogs/
here they shall ever stay/till the buzzards take them away" and on the
reverse "29th March 1836." Collection of Bert and Jane Hunecke.*

two years after his purchase, Robert Mathis sold his share of the business to
Dr. Jasper Gibbs, creating Rhodes Ramey and Gibbs. Ramey and Company, a
partnership between Nathaniel Ramey, Jasper Gibbs, and John Hughes, was formed
in January 1939. During the same period, Collin Rhodes was the overseer for
Ramey and Hughes Pottersville Merchants, which was selling hundreds of gallons
of stone-ware, "flour pots," and brick. The same year, Dr. Jasper Gibbs married
Laura Jane Drake, daughter of the late Harvey Drake and Reuben's niece, in
Edgefield on May 7, and in October he sold his interest in the factory. Business
partners change again, and by 1840, Jasper and his brother James W. Gibbs are the
owners of the factory. In 1842, J. Gibbs and Company was divided into six shares
and owned by John Hughes, James W. Gibbs, Jasper Gibbs, Sandford Gibbs, John
D. Nance, and an unknown party. While the ownership changed frequently, the
factory continued to produce pottery in good quantities, due to the work of enslaved
African American potters like Abram, Dave, Daniel, Harry, and old Harry. Five
years later in 1847, Jasper Gibbs and his young family moved to Bienville Parish.
By 1850, Frances W. Pickens was the owner of the factory, having purchased it
sometime between 1842 and 1850.[17]

Jefferson S. Nash, related to the owners of Pottersville through marriage, made his way to Texas with stops in Georgia and Louisiana. He operated a pottery for a short time in Marion, Texas, where wares bearing his stamp, "J. S. Nash," and having the characteristics of Edgefield pottery, were produced. Two pieces of stamped pottery survive today. One, a jug with a double ringed neck and strap handles, ovoid-shaped body, and light-colored alkaline-glaze (fig. 10). It bears a striking resemblance to a double-ringed-neck jug with strap handles, decorated with kaolin slip, made in 1850 at the Collin Rhodes factory in Edgefield (fig. 11). The dimensions of the Rhodes jug are quite similar, at 17 ½ inches tall with a circumference of 39 inches. These works were produced at factories where consistency of form and size was desired. The variation in size could be attributed to difference in shrinkage rates between the clay bodies. The second Nash piece, a large jar in the Bayou Bend Collection, the Museum of Fine Arts, Houston, has an iron-slip swag decoration and four applied slab handles (fig. 12). It echoes the decorative style used at the Phoenix Factory and the Rhodes Factory. This type of decoration was not common among pottery produced in Georgia, Alabama, or Texas.

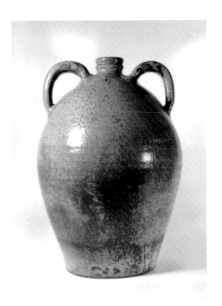

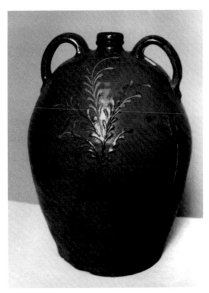

Fig. 10. Jefferson S. Nash. **Jug.** *c. 1850. Alkaline-glazed stoneware, 16 ½ x 12 in. (41.9 x 30.5 cm). Stamped "J. S. NASH". Private collection.*

Fig. 11. Collin Rhodes Factory. "Scott & Ewart" **Jug.** *c. 1850. Alkaline-glazed stoneware, 17 ½ x 12 ½ in. (44.5 x 31.7 cm). McKissick Collection, University of South Carolina.*

Nash was born in Georgia around 1802. He was not named in the 1820 census for either Georgia or South Carolina, not unusual for a young man of eighteen. Jefferson Nash does appear in the 1830 census for Monroe County, Georgia, and then in Henry County, Georgia, in 1840. His wife, Elizabeth Gibbs Nash, sister of James and Jasper Gibbs, inherited 480 acres in Texas upon her brother James's death in 1849. Jefferson Nash was the executor for Gibbs estate. By 1850, he, his wife, and six children were listed in a census for Cass County, Texas. Elizabeth's sister Mary Gibbs moved to Texas with them. It is interesting to note that Nash is listed as a farmer in both the 1850 census (Cass County) and the 1860 census (Marion County). A "J. A. Watts" and another young man are listed as turners within the Nash household during the 1850 census. It is probable Nash was the owner of a pottery business as well as the first iron foundry in Texas that and his eldest son, William D., established in 1847.[19] Cooper Nash, possibly Jefferson's brother, was living in Rusk County, Texas, in 1850; this is the county where the Leopards and Cogburns were living and working as potters.

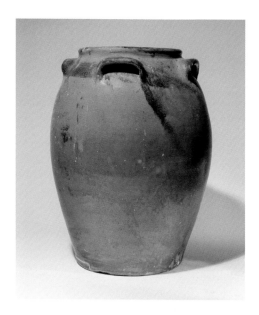

Fig. 12. Jefferson S. Nash Pottery. **Storage Jar.**
c. 1850. Alkaline-glazed stoneware, 19 ½ in. x 12 ¾ in.
(49.5 x 32.4 cm). The Bayou Bend Collection, museum
purchase with funds provided by the Ima Hogg Ceramic
Circle, B.82.2.

The Kirbees are another pottery family with ties to both South Carolina and Texas. James Kirbee, listed in the 1830 census for Elbert County, Georgia, was living Montgomery, Texas, by 1840. His son Lewis married Frances King in Elbert, Georgia, in 1836. Five years later, in 1841, Lewis Kirbee and Lewis Miles witnessed a document for Amos and John Landrum, which indicates there was a continuous relationship between the Kirbees in Georgia and Texas with South Carolina. Lewis Miles was John Landrum's son-in-law and lived nearby, where he operated a pottery and mill. It is unknown whether Kirbee was a business associate of or related to Lewis Miles and John Landrum, or if he learned the pottery trade from the Landrums before moving to Texas, where he operated his own stoneware manufacture. If so, Lewis Kirbee worked with Dave, who in 1840 wrote the rhyme "Dave belongs to Mr. Miles, where the oven bakes and the pots bile."[20]

The rest of the Kirbee family eventually moved into Montgomery, Texas, and operated a pottery from 1850 into the 1860s. Kirbee's kiln, according to the late Texas ceramics scholar Georgeanna Greer, was one of the largest "ground-hog," or dug-out, kilns in the South. Archaeological fragments found at Kirbee's kiln site bear the alkaline-glaze developed in Edgefield. The forms of the vessels are also similar to those produced in Edgefield during the early nineteenth century. Several shards found at the Kirbee site are stamped with an "O."[21] Many Pottersville pieces are similarly marked with letter stamps, among them "A" and "P"; the maker's marks of an "x" were also found on ware made at Reverend John Landrum's pottery (see fig. 4).

According to Greer's analysis of the census records and the list of those operating potters in Texas during the 1850s, the Kirbee Pottery was not as productive as the Cogburn or Prothro factories, as the Kirbee Pottery's output did not exceed a value of $500 in annual product. Prothro Pottery in Chalk Hill, Texas, produced 10,000 gallons of stoneware annually at a value of $2,500. T. I. Cogburn's pottery in Sand Hill, Rusk County, Texas, also produced ten thousand gallons of stoneware, valued at $2,500.[22]

In comparison, Lewis Miles Factory employed seven men and two women and produced forty thousand gallons of stoneware, valued at $4,000 in 1850. Thomas Chandler employed eleven men and women and his output was valued at $2,500.[23] Collin Rhodes employed three men and three women and the stoneware was valued at $2,000. The difference in value could be attributed to the close proximity of the potteries and increased competition in Edgefield, whereas in Texas there was a good bit of distance between the potteries. In 1860, Lewis Miles Pottery, with Dave as the master potter, produced fifty thousand gallons of ware annually and was valued at $5,000, an increase of $1,000 in value over a ten-year period.

Advertisements promoted the quality of the works along with the standard sizes available for sale. Thomas Chandler was working with Collin Rhodes and Robert Mathis at the Phoenix Factory site in the 1840s. They were advertising their decorated wares as being of "warrantable" quality. Many of the vessels were inscribed "Warranted" or with the stamp of the factory, "Phoenix Factory / SC." Years later, Thomas Chandler parted company with Collin Rhodes and established his own factory, marking his vessels, "Chandler Maker" and advertised as such (fig. 13). Thomas Chandler and Dave were the two potters in Edgefield known to make vessels larger than twenty gallons. The very large jars began to appear in the 1840s, shortly after Thomas Chandler moved into the area. Chandler produced unusually tall water coolers, including one with a slave wedding scene on the side, and another with a fine celadon glaze and kaolin slip decoration. By 1843, Dave was turning very tall vessels over twenty inches in height (fig. 14).

Pottery was also produced and marketed for merchants in Columbia, Hamburg, and Lexington, South Carolina. Many of these merchant jugs were decorated with kaolin slip, a method quite different from the inscriptions on works from Lewis Miles Pottery. Several of the extant pieces also bear the mark of the Collin Rhodes factory, "C. Rhodes Maker."

Stone Ware!

THE Subscriber believing that a good article of this useful and necessary Ware is much needed, has come to the conclusion to make and keep on hand a splendid article, which he will not only recommend, but will *warrant* to be good.

He, therefore, most respectfully solicts the patronage of those who deal in and use this kind of Ware, knowing that they will be satisfied with his Ware and prices.

All orders directed to me at Kirksey's X Roads, Edgefield District, S. C., will meet with prompt attention.

My Jugs are marked "Chandler Maker,— Warranted." T. M. CHANDLER.

May 15, 6m 17

Fig. 13. Advertisement for Thomas Chandler's business, **Edgefield Advertiser**, *May 15, 1850. South Caroliniana Library, University of South Carolina.*

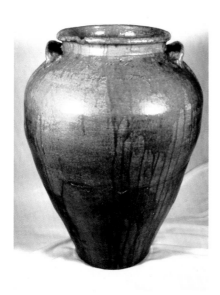

Fig. 14. David Drake, Lewis Miles Factory.
Storage Jar. *May 16, 1843. Alkaline-glazed stoneware, 27 x 22 ½ in. (68.6 x 57.2 cm). Private collection.*

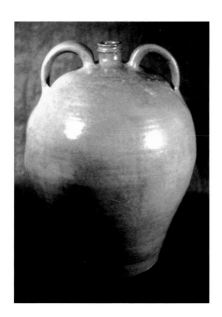

Fig. 15. David Drake, Lewis Miles Factory. **Syrup Jug.** *January 29, 1840. Alkaline-glazed stoneware, 17 ¼ x 14 in. (43.8 x 36.6 cm). Incised "Ladys & gentlemens Shoes: / sell all you can: & nothing you'll loose!" and on the reverse, "January 29th 1840 L Miles Dave." Collection of Dr. and Mrs. John E. Hoar.*

The 1840s two-handled jug with the lines "Ladies and Gentlemens Shoes / Sell all you can and nothing you'll loose" (fig. 15) turned by Dave is also very similar in form and size to the J. S. Nash jug (see fig. 10) and the Scot & Ewart jug made at the Collin Rhodes factory in 1850 (see fig. 11).

Pottery was distributed by wagon and railway after 1833 and until the late part of the nineteenth century. Potters advertised that goods could be delivered to the depot in Charleston. About twenty years later, a railroad line was located near Lewis Miles Pottery. The pottery produced by Dave at the Lewis Miles factory was primarily fashioned out of the iron-rich clay, which if under fired would have the appearance of earthenware as seen in the porous surface of a large jar created August 24, 1857 (fig. 16). Similarly, the glaze found on many pieces made in 1857 was a very iron-rich alkaline-glaze, which fired to a shiny, almost iridescent brown. If fired at too high a temperature, the glaze would turn almost black, as seen in a jug incised "Panzebider Groceries" (fig. 17). This jug fired to a different appearance than a jar that was also made for this grocer, now in the collection of the Charleston

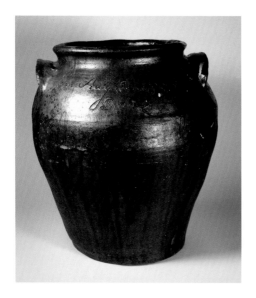

Fig. 16. David Drake, Lewis Miles Factory. **Storage Jar.** *August 24, 1857. Alkaline-glazed stoneware, 19 x 17 ¼ in. (48.3 x 43.8 cm). Incised "A pretty little girl on a verge / volca[n]ic mountains how they burge / Dave" and on the reverse, "Lm Aug 24 1857 Dave." McKissick Museum, University of South Carolina.*

Museum. The Panziebieter Grocery was at the corner of King and Columbus streets in Charleston, near the present-day headquarters for the *Charleston Post and Courier* newspaper and two blocks north of the railroad depot, now the Charleston Visitor Center and across the street from the Charleston Museum. A pitcher was excavated from a privy off of Judith Street, a block from the railroad depot in Charleston. It is among the very few pieces of Edgefield pottery among archaeological fragments found in the city.

When the Charleston Museum began collecting and documenting Edgefield pottery in the 1919, numerous examples were obtained from people who lived along the South Carolina railroad lines. The museum collected two of the largest hand-made pieces of stoneware produced in the United States during the nineteenth century. Dave and Baddler (most likely another slave) made these mammoth vessels while working at Lewis Miles factory on May 13, 1859, a mere three days after Arthur Simkins's newspaper musings about Dr. Landrum, Dave, and Pottersville. The museum acquired the first jar in February. It bears the following verse:

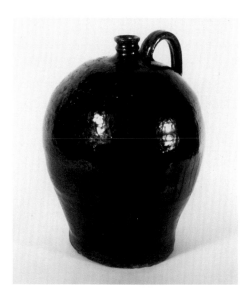

Fig. 17. David Drake, Lewis Miles Factory. **Syrup or Whiskey Jug.** *c. 1858. Alkaline-glazed stoneware, 14 ¾ x 11 ½ in. (45 x 29.2 cm). Incised "Panzebider / Groceries / King and Columbus Streets / Charleston / S.C." Collection of Larry and Joan Carlson.*

"Made at Stoney Bluff— / for making [lard] enuff." The second jar they acquired a month later from another source which bears the verse, "Great & noble jar / hold sheep, goat and bear" (fig. 18).[24] These forty-gallon vessels were made in three and four sections. The first section was thrown on the wheel, the second and third sections were possibly coiled on—or turned on the wheel to the appropriate diameter—and then added to the body of the pot until the desired height and capacity were reached. Before firing, the pots would have weighed between two hundred and two hundred forty pounds. The glaze was poured over and down the sides of the pot, which can be seen in the drips. Areas of blue puddling appear along the handles and can be explained by the natural occurrence of rutile, or titanium dioxide, making its way through the glaze or by the deliberate placing of blue glass on the handles to strengthen the attachment as well as for decorative effect. The latter was a technique employed at the potteries operating in the Catawba Valley of North Carolina.

Dave continued to work up through the Civil War, writing poems with biblical references such as "I saw a leopard & a lions face / then I felt the need of grace" written twice; first on November 3, 1858 and then again on August 7, 1860 (fig. 19).

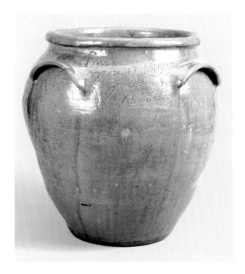

Fig. 18. Dave and Baddler, Lewis Miles Factory. **Food Storage Jar.** May 13, 1859. Alkaline-glazed stoneware, 25 ¾ x 26 in. (65.4 x 66 cm). Incised "Lm / May 13 1859 / Dave & / Baddler" and on the reverse, "Great & Noble jar, / hold sheep, goat and bear". Collection of the Charleston Museum, South Carolina.

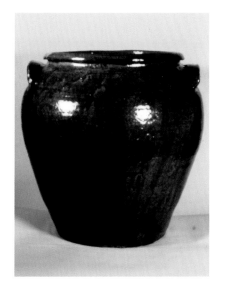

Fig. 19. David Drake, Lewis Miles Factory. **Food Storage Jar.** *August 7, 1860. Alkaline-glazed stoneware, 16 ¾ x 17 ¼ in. (42.5 x 43.8 cm). Incised "Aug 7 1860 Dave" and on the reverse, "I saw a leopard & a lions face / then I felt the need of grace."*

Fig. 20. David Drake, Lewis Miles Pottery. **Storage Jar.** *March 31, 1864. Alkaline-glazed stoneware, 15 x 12 ¼ in. (38.1 x 32.4 cm). Incised "Lm March 31 1864 / Dave." Collection of Lou Edens.*

The last dated verse, "I - made this Jar all of cross / If you don't repent, you will be lost" was written on May 3, 1862. The jars became smaller as the years progressed, indicating Dave's advancing years as well as the changing needs of the local population as the plantation system was abolished.

Pots made by Dave with dates after 1864 have not surfaced, but they may be out there. The latest known dated jar, bearing the inscription, "Lm March 31 1864 / Dave" originally held food in a kitchen house (fig. 20). During the pot's long life, it journeyed to the middle part of the state, passed through three or four generations, was relegated to the back yard and painted institutional green, then saved by a family member who removed the paint and then used it as a stand for umbrellas and tennis rackets. The pot had traveled more than one hundred miles to the coast of South Carolina and narrowly escaped destruction when the front door of the owner's house was blown in as the eye of Hurricane Hugo passed over Mt. Pleasant and Charleston on September 21, 1989.

African-American Potters after the Civil War

The occurrence of former slaves working as potters after the Civil War was not isolated to South Carolina. These men often took the same surname as their former owners who operated the potteries: Cribbs, Presley, Williams, and Rushton in Alabama, Chandler, Cogburn, Frazier, and Wilson in Texas; Drake and Miles in South Carolina.[25]

The story of the Wilson Pottery is similar to that of the Lewis Miles Pottery, where enslaved potters who were working for Lewis Miles in Edgefield and those working for John Wilson in Texas continued the pottery business several years after the Civil War.[26] The Wilsons were producing pots that reflect the change in the economy away from the plantation system and the need for enormous vessels. The pots are not huge in capacity—the largest being five gallons, which was typical of the late nineteenth century. The vessels became more cylindrical in form with straight walls and small handles (fig. 21). This change occurred as a means to fit more pots in the kiln during firing. The stamping of the vessels with the maker/pottery name became more consistent, as did stamping the ware with a numeric capacity. The major difference between the Wilson Pottery and the Edgefield potteries was the glaze. The Wilsons used the salt glaze when they fired.

In Edgefield, after the Civil War ended, many of the former slaves continued to work at the Lewis Miles Pottery at Miles Mill. Lewis Miles died in 1869, and his son John continued the business for at least another decade. Josh Miles, who was a black man, operated a pottery not far from Miles Mill with the assistance of six male and female laborers. One of those men was "Uncle" Jack Thurman, the mulatto son of Lewis Miles. The manner in which the handles were attached on a stoneware jar attributed to Jack Thurman shows similarities to the vessels made at the Wilson pottery (fig. 22). This could be attributed to changes in style and the idiosyncrasies of the individual potter. As the capacity of the jars decreased, so did the size of the handles. It is interesting to compare the output and value of the three potteries operating in the Shaw's Creek area of Aiken County. John Miles, Ben Landrum, and Josh Miles were listed in the Industrial Census of 1879–80 for their stoneware factories. Josh Miles' factory employed the fewest number of people (six) and paid the lowest wages ($100 average yearly wages for a skilled worker), yet the output was valued the highest among the three, at $6,000.

The ceramic tradition in Edgefield dwindled at the end of the nineteenth century and died out by 1920; it endured in other areas of South Carolina, Georgia, Alabama, and Texas because the potters adapted their goods and glazes to meet changing demands.

Fig. 21. H. Wilson & Co. **Storage Jar.**
c. 1869–84. Salt-glazed stoneware, 14 x 9 in.
diameter. The Museum of Fine Arts, Houston,
Bayou Bend Collection.

Fig. 22. Attributed to Jack Thurman, Miles Mill.
Storage Jar. c. 1890. Alkaline-glazed stoneware,
16 ¼ x 13 in. (41.3 x 33 cm). Collection of the
Charleston Museum.

Today

Many men and women have collected, researched, and written about Edgefield pottery and how its influence spread across the South. The history of pottery made in Edgefield has been researched by many people over the past one hundred years, beginning with Edwin Atlee Barber of Philadelphia in 1896. Texan Georgeanna Greer, who was a physician by career, was also an avid collector, researcher, and author of American pottery. She contributed to the study of Southern traditional pottery, beginning in Texas and moving east as she researched the men who established the potteries, many who lived in Alabama, Georgia, South Carolina, and North Carolina. Greer influenced many other ceramic scholars, including Joey Brackner, who wrote his master's thesis on the Wilson Potteries of Texas while a student at the University of Texas. Brackner has become the authority on the traditional pottery of Alabama. His recent publication, *Alabama Folk Pottery*, covers two hundred years of pottery production in that state to the present day. Several of the early potters in Alabama came from the Edgefield area by way of Georgia and produced alkaline-glazed stoneware; a few traveled westward to Texas.

Greer influenced the study of Edgefield pottery when her collection was surveyed by Cinda Baldwin of McKissick Museum at the University of South Carolina. Her research on the alkaline-glazed stoneware was published in the exhibition catalogue *Crossroads of Clay: The Southern Alkaline-Glazed Stoneware Tradition*. Baldwin's own research emerged from *Crossroads of Clay* into the excellent publication *Great and Noble Jar: Traditional Stoneware of South Carolina*, the first comprehensive history of stoneware production in the state and how the tradition moved westward and survived. It encompasses archaeological research, folklore, and a material culture approach to the topic. This work provided the framework for my research on David Drake, and it continues to educate and inspire.

Dr. John A. Burrison, professor of English and Folklore at Georgia State University, also discourses over the connections between Edgefield and the early stoneware potters of Georgia. He delves into the history of Cyrus Cogburn and Abraham Massey as they worked in Georgia and their activities with the Landrum families. His book *Brothers in Clay: The Story of Georgia Folk Pottery* defines the traditional familial relationship found among southern potters, a tradition that persists today and that mirrors that of English and European potters. Burrison has also collected Southern traditional pottery for nearly forty years, of which a large portion is on display at the Atlanta History Center and at the Museum of North Georgia Folk Pottery.

Turners and Burners by Dr. Charles Zug, professor of folklore at the University of North Carolina at Chapel Hill, provides the history of North Carolina's rich ceramic traditions, including that of alkaline-glazed stoneware and the areas of the state where that type of glaze was predominately used.

The scope of work about Southern traditional pottery has grown exponentially since the 1960s. The discourse about Southern pottery and potters continues as contemporary potters explore the old forms and traditions and as collectors, archaeologists, genealogists, folklorists, historians, anthropologists, and art historians find and research the families and "new" old pots. Of course, museums continue to play an important role as they collect and exhibit American ceramics and demonstrate how these vessels are much more than functional or beautiful, but have a complex and compelling story that is told from the viewpoint of material culture.

Notes

1 *Edgefield Advertiser*, May 11, 1859, vol. 24, no. 18.

2 John Winberry, "The Cultural Hearth of the Southern Pottery Tradition: The Historical Geographic Framework," in *Crossroads of Clay: The Southern Alkaline-Glazed Stoneware Tradition*, ed. Catherine Wilson Horne (Columbia, S.C.: McKissick Museum, University of South Carolina, 1990), 7–8.

3 Robert Mills, *Statistics of South Carolina* (Charleston: Haurlbut and Lloyd, 1826), 523–24. Orville Vernon Burton, *In My Father's House Are Many Mansions* (Chapel Hill, N.C.: University of North Carolina Press, 1985), 34.

4 Catherine Wilson Horne, *Crossroads of Clay: The Southern Alkaline-Glazed Stoneware Tradition* (Columbia, S.C.: McKissick Museum, University of South Carolina, 1990), x.

5 Report of the Committee on the Governors message, No. 1, upon the petition of Abner Landrum, December 14, 1812, South Carolina Department of Archives and History.

6 Cinda Baldwin, *Great and Noble Jar: Traditional Stoneware of South Carolina* (Columbia, S.C.: McKissick Museum; Athens, Ga.: University of Georgia Press, 1993), 17–19.

7 Land purchases made by John and Amos Landrum on Horse Creek, John and Abner Landrum on Horse Creek, November 11, 1808. On-line search, South Carolina Department of Archives and History. Amos and Harvey purchased land at Stephen's Creek in 1825.

8 Bradley Skelcher, "Review of James David Miller, *South by Southwest: Planter Emigration and Identity in the Slave South,*" *H-South, H-Net Reviews,* August 2004. http://www.h-net.msu.edu/reviews/showrev.cgi?path=323821094926599.

9 Correspondence, Thomas Cooper to Dr. Cohen, April 9, 1830. Copy from original in Geology Department files, McKissick Museum, University of South Carolina, Columbia, S.C. At the time, Cooper was President of the South Carolina College, a position he held from 1821 to 1833. He was a noted scientist as well as a friend of President Thomas Jefferson's and was influential in the realm of South Carolina politics.

10 Handbook of Texas Online, Texas State Historical Association, "Bonham, James Butler," http://www.tshaonline.org/handbook/online/ (accessed May 5, 2007).

11 Burton, *In My Father's House,* 95–98.

12 Baldwin, *Great and Noble Jar,* 74.

13 Jill Beute Koverman, *I Made This Jar…: The Life and Works of the Enslaved African-American Potter, Dave* (Columbia, S.C.: McKissick Museum, University of South Carolina, 1998), 23. See also Edgefield County Probate Records, Estate of Harvey Drake, box 9, package 304, microfilm reel #ED8, South Carolina Department of Archives and History.

14 Baldwin, *Great and Noble Jar,* 36–39.

15 "To Witness the Past: African American Archaeology in Alexandria" online exhibit, http://oha.alexandriava.gov/archaeology/ar-exhibits-witness-3.html (accessed May 16, 2007).

16 1850 Federal Census, Bienville Parish, Louisiana, 561 or 261.

17 Baldwin, *Great and Noble Jar,* 194. see also account book/ledger, "Ramey and Hughes Merchants, Pottersville, South Carolina," South Carolina Historical Society.

18 Michael K. Brown, *The Wilson Potters: An African-American Enterprise in Nineteenth-Century Texas* (Houston: The Museum of Fine Arts, Houston, 2002). This reference indicates that Nash was the executor of Jasper Gibbs estate, but most likely it was the estate of James William Gibbs (brother to Jasper). Nash was married to James's sister Elizabeth, who was the recipient of 480 acres of land in Cass County, Texas. In 1850, Dr. Jasper Gibbs lived in Bienville Parish with his wife, Laura Jane (Drake) and their three children. (1850 Census, Cass County, Texas; 1850 Federal Census, Bienville Parish County, Louisiana). Gibbs would later move to Mexia, Texas, after his wife Laura died, and he subsequently remarried.

19 *Handbook of Texas Online,* s.v. "Nash's Iron Foundry," http://www.tsha.utexas.edu/handbook/online/articles/NN/dkn1.html (accessed February 1, 2007).

20 Baldwin, *Great and Noble Jar,* 65; James M. Malone, Georgeanna H. Greer, and Helen Simons, *Kirbee Kiln: A Mid-Nineteenth-Century Texas Stoneware Pottery* (Austin: Office of the State Archaeologist, Texas Historical Commission, 1979), 52.

21 Malone, Greer, and Simons, *Kirbee Kiln*, 3–11.

22 Ibid., 46.

23 1850 Federal Industrial/Manufacturing Census, South Carolina Department of Archives and History.

24 Koverman, *I Made This Jar*…,19

25 Brackner, Joey, *Alabama Folk Pottery* (Tuscaloosa, Alabama: The University of Alabama Press, 2006), 11.

26 Brown, *The Wilson Potters*, 15–19.

27 Baldwin, *Great and Noble Jar*, 89–90.

David B. Warren is Founding Director Emeritus,
Bayou Bend Collection and Gardens.

Margaretta M. Lovell is Professor of the History of Art
and the Jay D. McEvoy Professor of American Art,
University of California, Berkeley.

Kelly Donahue-Wallace is Associate Professor of Art History,
University of North Texas, Denton.

Lonn Taylor is an independent historian based in Fort Davis, Texas.
He was formerly Historian, Smithsonian Institution, National Museum
of American History, Washington, D.C., and is currently on the
board of the Texas State Historical Association.

Jill Beute Koverman is Curator of Collections, McKissick Museum,
University of South Carolina.

Front cover: photograph by Thomas R. DuBrock,
department of photographic services, The Museum of Fine Arts, Houston.
Back cover: photograph by Rick Gardner.

A Gift of Love: Miss Ima Hogg's Quest to Bring Americana to Texas
David B. Warren
Unless noted, photographs of works of art in the Bayou Bend Collection are by
Thomas R. DuBrock, department of photographic services, the Museum of Fine Arts, Houston.
Figs. 9, 10, 25, 26, 40, 41, 43, 45, 46, 47, 48, 49: photographs by Rick Gardner.
Fig. 12: photograph by Miguel Flores-Vianna.
Fig. 23: photograph by F. Wilber Seiders.
Fig. 31: photograph by Bert Brandt and Associates.
Fig. 44: photograph by Curtis L. Bean.

American Material Culture: Artists, Artisans, Scholars, and a World of Things
Margaretta M. Lovell
Figs. 1, 6, 9: photograph by the author.
Fig. 2: photograph by Thomas R. DuBrock, department of photographic services,
the Museum of Fine Arts, Houston.
Fig. 4: photograph by Rick Gardner.
Fig. 7: Mount Vernon Ladies' Association.
Fig. 10: Archives of Yale University Art Gallery.

A Journey of a Thousand Miles Begins with a Lot of Luggage:
Spanish Colonial Material Culture in the U.S. Southwest
Kelly Donahue-Wallace
Figs. 2, 4: photographs by the author.
Figs. 5, 7, 8: Bridgeman Art Library.

Sweet Potatoes and Cicero: Furniture and Furniture-Making
in the German Settlements of Texas
Lonn Taylor
Figs. 1, 2, 6, 20: photographs by the author.
Fig. 7: photograph by Ewing Waterhouse.
Figs. 8–19: photographs © Center for American History, University of Texas at Austin.

Clay Connections: A Thousand-Mile Journey from South Carolina to Texas
Jill Beute Koverman
Fig. 1: photograph by the author.